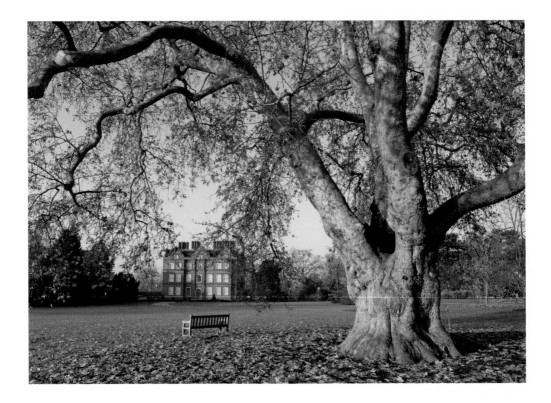

at the ROYAL BOTANIC GARDENS KEW

PORTLAND PRESS

GlaxoSmithKline (GSK) is pleased to be working once again with the Royal Botanic Gardens, Kew as part of our community investment programme: sponsorship of *Gardens of Glass: Chihuly at Kew* is our fourth major collaboration. With global headquarters near to the Gardens, it gives us great pleasure to be supporting an exhibition of international interest that is so close to home and is an innovative departure for Kew—an organisation more usually noted for its science-based activities.

Gardens of Glass: Chihuly at Kew is the latest in a series of landmark exhibitions that GSK has supported in recent years, which includes *El Greco* and *Art in the Making: Underdrawings in Renaissance Paintings* at the National Gallery and *American Sublime* and *William Blake* at Tate Britain. Our collaborations with community partners are built on a shared commitment to excellence and innovation.

Themes of discovery are fundamental to a research-based company like GSK; in supporting *Gardens of Glass: Chihuly at Kew*, we hope that visitors will discover links between science, art, and nature, and leave Kew with a greater appreciation of the place of art in an environmental setting.

PLANTS PEOPLE
POSSIBILITIES

Royal Botanic Gardens, Kew,
Richmond, Surrey TW9 3AB, UK
Telephone +44 (0)20 8332 5000
Facsimile +44 (0)20 8332 5197
www.kew.org

The Royal Botanic Gardens, Kew is many things to many people: a refuge from hectic city life, a world-renowned scientific organisation; a unique place to learn; and an important historical landscape that boasts imposing gardens, stunning glasshouses, Georgian architecture, and Victorian vistas. Kew also has wild areas where Nature can be savoured and where Britain's native plants and animals can thrive. And behind the scenes, there are internationally important collections of living and preserved plants, the world's greatest collection of botanical art, a vast and distinguished library, and scientific research programmes that inform the conservation of plants throughout the world.

With all these riches, at one level Kew needs no adornment. What could possibly improve on the beauty and wonder of Nature? But at another level, Kew's role is not simply to display the diversity of plant life, but to draw attention to it. Our aim is to encourage our audiences to engage with plants. We want them not only to look, but also to see. Dale Chihuly's magnificent glass sculptures help us see the natural world in a new way. They challenge us to compare the elegance and beauty of man-made form and man-made materials, with the shapes, colours, and textures of plants. And they encourage us to reflect on the processes by which similar forms in different materials came to be.

Over one million visitors a year explore the Kew World Heritage Site, including visitors from overseas, people from across the United Kingdom, and more than 120,000 children. This exhibit will bring many more visitors of all ages and backgrounds to Kew. In the process, we hope they will not only gain a new appreciation of the beauty of Nature, but that they will also leave delighted and enchanted by the interplay of Nature and art.

We are delighted to host the art of Dale Chihuly here at Kew, and it is a great pleasure to be able to acknowledge publically the many people who have brought this exciting project to fruition. Through the combined efforts of the Kew and Chihuly teams, "Chihuly at Kew" welds the vision of the world's greatest living master in the medium of glass, with the incomparable beauty of Nature. We hope that you enjoy the results of this unique partnership.

Professor Sir Peter Crane, Director

SAVING THE WORLD'S PLANTS FOR LIFE

Royal Botanic Gardens Kew has exempt charitable status.
Printed on 100% recycled paper.

INVESTOR IN PEOPLE

ROYAL
BOTANIC
GARDENS
KEW
WORLD HERITAGE SITE

FRONTISPIECE Kew Palace in the autumn

CONTENTS

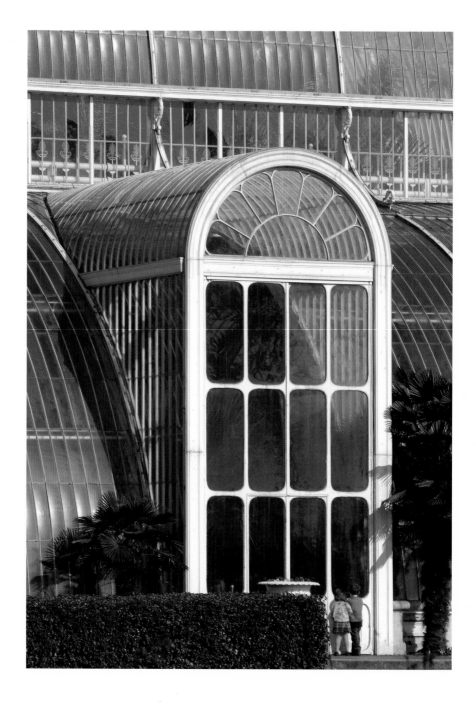

WHEN IS A DOOR A JAR?

DALE CHIHULY'S UNCANNY MATERIALITY

TODD ALDEN

It is often said that the establishment of botanical gardens and zoological collections expressed a new curiosity about exotic plants and animals. In fact, these had already claimed men's interest for a long while. What changed was the space in which it was possible to see them and from which it was possible to describe them.

Michel Foucault [1]

Visitors arriving at Kew Gardens from Victoria Gate are welcomed by Dale Chihuly's glistening multiplicity of glass installations, consisting of myriad accumulations of individual many-colored, irregularly shaped glass forms. Together with a fanciful scattering of colorful, buoyant, onion-like orbs, one of the first things sighted is a Thames Skiff floating on the reflecting pond before the great Palm House. Filled with Chihuly's riotous art, this local, nineteenth-century-type vessel is refashioned into a raucous, drunken boat containing the artist's signature, brightly hued and delightfully idiosyncratic, handblown glass. Like the rest of his work, the shapes of these abstract passengers are frequently repeated but never identical; as always, they are irregular and wondrous, here ranging from the bulbous to the horn-like. The proliferation of reduplicating, shimmering forms by Chihuly—proverbially the King of

Glass—surprises the viewer with both unexpected placement and unapologetic aesthetic presence that displaces the static, utilitarian order of the historic Royal Botanic Gardens with unexpected, reflecting forms. In botanic, but also art, contexts, the material itself, glass, confounds the familiar received ideas about what is typically found inside a botanic garden and what is art. This "uncanny materiality"[2] disarranges the viewer's anticipation of finding nature—not culture—in a botanic space and also unsettles the viewer's expectations of finding a static, unitary artwork. Also disarranged, of course, are the viewer's expectations of finding glass not as a utilitarian container or boundary, as is the case, for example, in jars and greenhouses. Chihuly's art, in fact, turns inside out the form of glass as a container, transforming it instead into a series of reflective surfaces, devoid—and more precisely, *de-voided*—of

PREVIOUS Two small children gaze through the massive front door of the Palm House

utilitarian prescription and containing functions. Making flippy-floppy, Dale Chihuly's multiplying glass forms are anti-forms. We see them as a series of reflections whose accumulative, syntactic effect defies stability of reference or meaning. Deploying structures of reversal, reflection, and collapse, Chihuly glassworks transform the familiar into the unfamiliar under the aesthetic regime of the uncanny.

Of course, the materiality of glass, on both the structural and psychological levels, contradicts the stability of forms; it is precisely its anti-unitary materiality that lends glass its uncanny character, its special capacity to elicit a certain kind of fear, otherwise known as "nelophobia" (fear of glass), that is said to be universal. Although glass enjoys the alchemical aura of somehow being considered as a "natural" material, it is almost never found in nature. Made from sand and sulfur at unusually high temperatures, it is a maverick, unstable, culture-bound substance; scientists do not consider it to have a stable state, in fact, but rather, to be an unusual, "rigid liquid." Chihuly explores these idiosyncrasies of the magical or chimerical aspects of glass. In opposition to familiar industrial forms of glass found, say,

in nineteenth-century glasshouse architecture, Chihuly surprises the viewer yet again with his deployment of handblown glass, curiously unfamiliar to twenty-first-century audiences.[3] Attracted as we are to it, we are also afraid of glass, of course, not only because of its reflective (and therefore redoubling) characteristics, but also for its perceived fragility and for the imagined and real power it has, when broken, to cut us to the quick.

Although he has taken a lifelong interest in glasshouse architecture, it was only with the artist's groundbreaking exhibition at Garfield Park Conservatory, Chicago, in 2002 that Dale Chihuly began conceiving large-scale installations of his own glass artworks inside botanic glasshouses. The site-specific installation at Kew Gardens, however, is his most ambitious botanical effort, partly because of Kew's central historical significance in the evolution of glass architecture, botany and natural history, and collecting. It is common for viewers to assume, especially in botanic contexts, that the artist's cultural work is designed to mimic or refer explicitly to floral and other natural forms— an interpretation not at all intended by the artist, even though he regularly encourages such false starts by sometimes retrospectively using

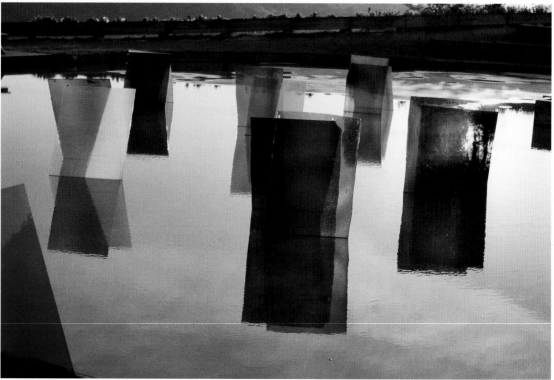

Artpark, 1975

natural references in the titles of his works and ongoing series, including *Mille Fiori*, *Saguaros*, *Reeds*, and, famously, *Seaforms*. Like Hamlet, who playfully goads Polonius into seeing a camel, a weasel, and a whale in the abstract shape of a cloud, perhaps Chihuly is only making sport with his deceivingly anchored, nature-bound titles.

Appreciating the infinite malleability of glass and its formal and anti-formal potential, the creative act, for Chihuly, always begins with the idea of inventing new procedures for violating established limits, for unfixing the boundaries or delimitations of the forms and functions of glass.

Chihuly's art, it needs to be said explicitly, is characterized by a rigorous commitment to abstraction. Although the botanic exhibition context simulates natural systems, Chihuly's work has less to do with reproducing nature than with restructuring cultural orders. Chihuly's serial dedication first to unconventional material procedures (and to formal rule-breaking in general), and second to open-ended serial forms and their changing

permutations, separates the artist from devotees of Craft and the great masters of glassblowing.

The artist's little-known changing installation of stained-glass sheets in and around the landscape of Artpark, in Lewiston, New York, in 1975, for example, provides a most obvious counterpoint to work made with respect to these latter traditions.[4] Conceived as a series of temporary installations, Chihuly installed the glass panes in reflecting pools of water and across the landscape, including inside rock crevasses. The changing installations were then lit by all types of artificial and natural lighting for the explicit purpose of being photographed. Like works by other artists at the time, notably those by Robert Smithson, Chihuly's documentation of work in non-art sites was instrumental in raising questions about the impermanent, transitory order of art and things; as Chihuly also understood, the documentation became the work itself. Without engaging a tired polemic against Craft traditions, suffice it to say that the serial, fugitive, and procedural characteristics of Chihuly's anti-unitary work relate it and the artist to the attitudes, anti-forms, and process-oriented concerns of the advanced art of the 1960s, including

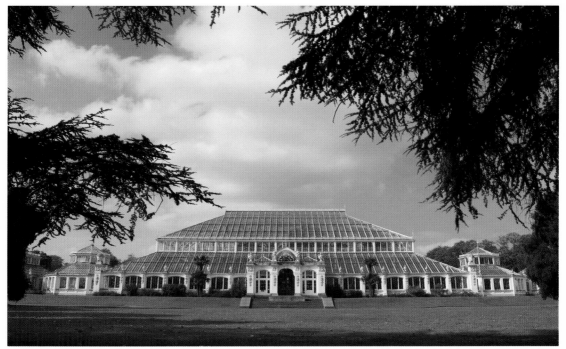

The Temperate House

13

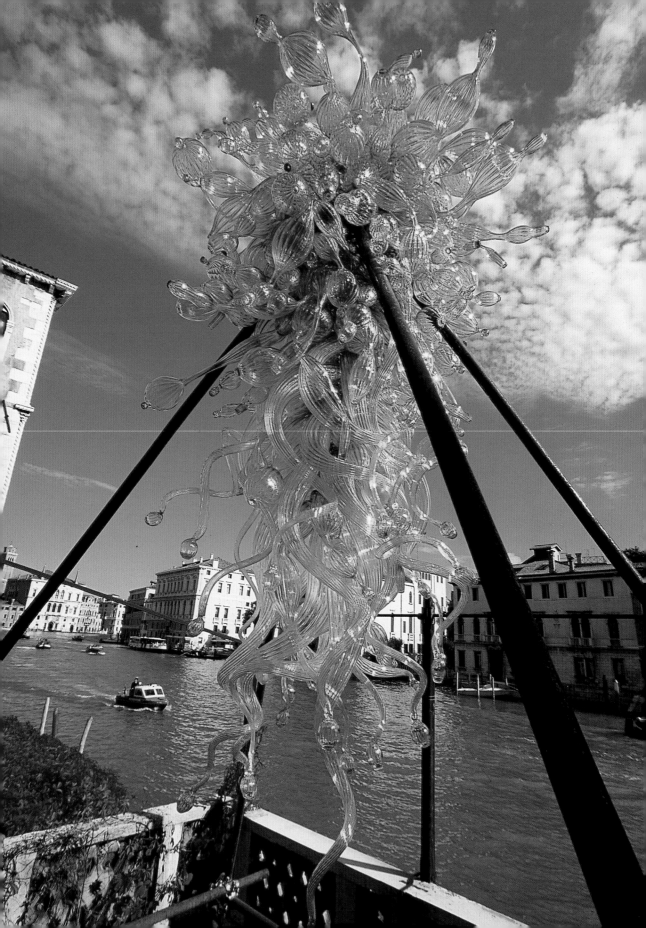

the Post-Minimalist legacy not only of Smithson, but also of Richard Serra, Eva Hesse, and Robert Morris.

Although Chihuly's work is frequently discussed as continuous with the tradition of the vessel, in fact, it almost always repudiates this other tradition with its long history of crafted forms or containers. The glasshouse (or greenhouse) in fact, is a *countertype* for Chihuly's art. The glasshouse was a nineteenth-century development of which Kew's Victorian Palm House (1844–48), originally designed by Richard Turner and Decimus Burton, was the vanguard, allowing for the necessary hothouse effect to make new botanic (and other) dreams possible. The Temperate House, begun around 1859, was at one time the largest plant house in the world. But more important, Kew was among the first botanical gardens where the vast heterogeneity of all the world's flora could be admitted, at least in principle, into the gates and glass of a single garden.

The novel architecture of Turner and Burton's influential glasshouse, interestingly, was made possible by the technology of British shipping, which had also recently developed a new type of iron, vessel form. Made of light but strong iron, the form of the great glasshouse resulted from the architect's inspired idea to invert the structure of an iron ship hull whose frame was strong enough to support vast areas of glass. Not unlike the popular impact that Chihuly's work exerts whenever it is exhibited at botanic gardens today, the success of the first glasshouse at Kew was striking: in 1850, just two years after the completion of the Palm House, annual attendance at Kew grew from 9,000 to reach more than 150,000.[5]

What does this have to do with Dale Chihuly? In his earlier days in Rhode Island and later in Seattle, Dale Chihuly opened studios by repurposing the architecture of former boathouses. Chihuly's contradiction, however, is that the artist's objects arrive out of a boathouse, but they are not themselves vessels. Reversing the boundaries of inside and outside, Chihuly's art abandons the container-like forms (jars, glasshouses) and functions of glass. One irony of this transmutation from use value to aesthetic value is that glass is both one of the cheapest materials known to man and, in Chihuly's case, also one of the most prized and collected.[6]

With Chihuly, as with Kew Gardens, the structures of collecting, vessels and glass are all related, albeit in curiously different manners. Different from

Palazzo di Loredana Balboni Chandelier, Venice, Italy, 1996

earlier types of gardens, Kew was established by Princess Augusta and Lord Bute during the 1750s according to Enlightenment principles of collecting that distinguished its new, clearly delimited shape.[7] In keeping with the type of tabulating impulse that also found expression in Denis Diderot's *Encyclopedia*—the first book setting out to contain "all the world's knowledge," and published during the course of two decades beginning in 1751—the Earl of Bute declared a serious botanic plan for Kew: it would be "a garden that would contain all the plants known on earth." But in addition to confining *nature* under a totalizing system—one that starkly contrasts with Chihuly's open-ended and collapse-threatening *culture*—Kew's garden had a very definite use value. Plants and seeds from all over the world were deposited and cultivated here, and Kew was chiefly responsible, for example, for introducing breadfruit to the West Indies and for establishing the so-called rubber economies of India and Malaysia.[8] Not long after the Palm House was built, railroads and steamers also arrived at this encyclopedic storehouse of flora, making Kew Gardens not just a nice, edifying place to stroll, but also something akin to the world's central bank of plants,

through which Empire was collected, reproduced, and redistributed.

With the transitions of the British Empire and with Chihuly's repurposing of glass, the functions of the botanic garden as an institution no longer depend so much on the usefulness of things (though the plants are still used extensively for research), but rather on the viewer's relationship to the space as an increasingly aesthetic one—but also, perhaps, as a context of play, as in a funhouse hall of mirrors. The capacity of Chihuly's work to captivate hundreds of thousands of viewers who otherwise would never find themselves in art's more traditional exhibition spaces should not be underestimated; here, Chihuly takes advantage of the art of surprise, placing proliferating forms, including asymmetrical *Towers*, on the long walk winding from in front of the Palm House. In addition there are also numerous installations at the Temperate House, dominated by the magnificently heterogeneous *Chandeliers*—including the *Palazzo di Loredana Balboni Chandelier*, itself the redoubling accretion of thousands of similar glass shapes. Above our heads, below the fronds of the world's oldest potted plant (1775), dotted across the Great Lawn, floating across the pond, and even placed in a boat (and just about

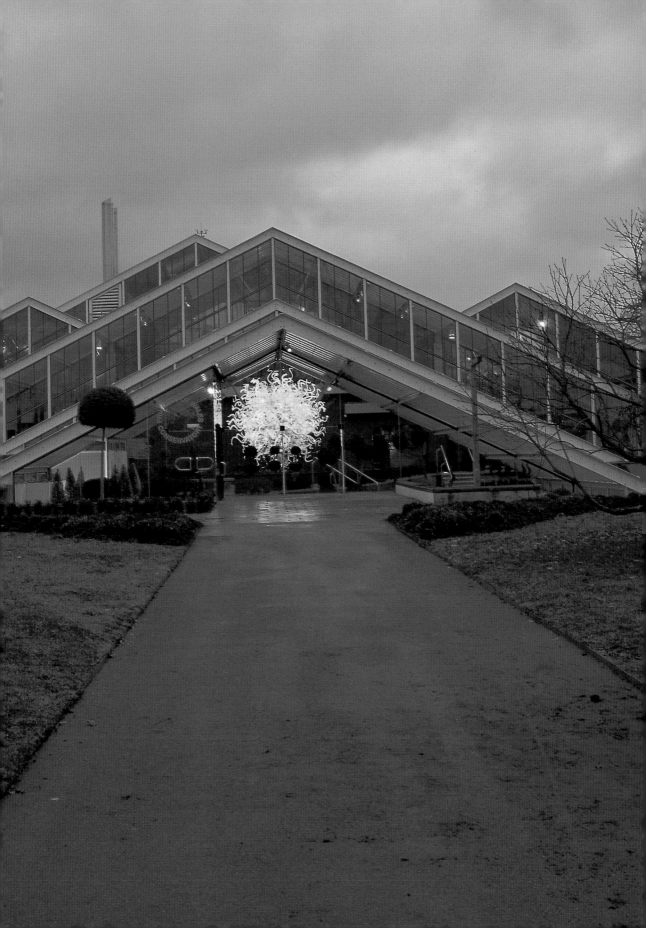

everywhere in the Princess of Wales Conservatory), Chihuly surprises us with his polymorphous collections of chimerical and uncanny materiality, giving us pause to find in the garden proverbial tongues in trees and books in brooks. Hardly a utilitarian system anymore, Chihuly's play of reflections and objects exacts, instead, a kind of enchantment more typically encountered at an Easter-egg hunt, as the artist himself has noted.

The curiously interconnected legacies of vessels, botany, and glasshouses at Kew Gardens provide the historical forms, boundaries, and foils for Chihuly's counter-typical, unfixed, and anti-unitary forms to collapse; Chihuly's uncanny aesthetics, with puckish élan, transform the familiar and the unfamiliar. Against the system of a principled garden, the artist's work counters with abstract, open-ended structures of free play in fugitive installations. As Chihuly understands, there is something decidedly disruptive —particularly to systems of order— about the idea of putting glass inside a glasshouse. Something of a *mise-en-abyme* (literally translated from the French as "put inside the abyss"), there is the implication of putting the *defined inside the definition* of something, of transforming the

glasshouse into a kind of hall of mirrors, an unstable system of representation for which there can never be a fixed significance.[9] In a way, putting glass inside a glasshouse shatters the unitary fiction of its boundaries, the fiction of its completeness. Evoked, instead, are structures of infinite reflection, collapse, and even the abyss. But even at the micro level, Chihuly's work and procedures consist of uncanny materiality and of maverick reversals of the boundaries between inside and outside, with each work already itself a series of reflections, with each work already reflecting the collapse of a glasshouse thrown at a glass house.

1608: **Captain John Smith's London Company sails to America with eight experienced glass blowers to found America's very first industr in Jamestown: a glass factory for making jars to be used as food containers (essentia for sustaining the new colony).**

2005: **Dale Chihuly ships about 20 tons o exhibition materials, including tens of thousand of pieces of handblown glass, from Seattl to London for temporary installation at Kev Gardens to be viewed by hundreds o thousands of visitors.**

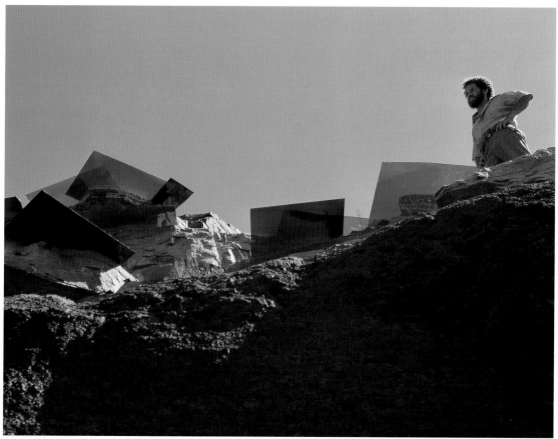

Artpark, 1975

1 Michel Foucault, *The Order of Things* (New York: Vintage Books, 1973), p. 131.

2 The phrase belongs to Robert Smithson, who "found the disappearance of the 'unitary' form behind a surface of reflections 'uncanny,' a disruption of what was expected from Minimalism," as paraphrased by Rosalind Krauss in "The Mind/Body Problem: Robert Morris in Series," in *Robert Morris: The Mind/Body Problem* (New York: The Guggenheim Museum, 1994), p. 15. Chihuly's seemingly endless proliferation of glass reflections, especially when installed in the great glasshouses, also conjures up this kind of "uncanny materiality."

3 Chihuly's use of mostly handblown glass contrasts, of course, with the Modernist use and celebration of industrially produced glass, for example, in Mies van der Rohe or Phillip Johnson's famous glasshouses. For an account of Mies's architecture in relationship to nelophobia, see Josep Quetglas, *Fear of Glass: Mies Van Der Rohe's Pavilion in Barcelona* (San Francisco: Birkhauser Verlag, 2001).

4 Chihuly's installation at Artpark was in collaboration with Seaver Leslie.

5 The impact of Richard Turner and Decimus Burton's glasshouse on the institutional legacy of both natural and art history cannot be overestimated and is certainly worthy of further discussion than this context allows. The very foundation of the Natural History Museum in London (along with other institutions, including the Victoria and Albert Museum) was made possible by the extraordinary royal profits reaped from the Great Exhibition at the Crystal Palace in 1851; its spectacular design by Joseph Paxton, also created for royal interests, was directly inspired by the Turner and Burton glasshouse at Kew. This is one rather poignant example of how the very existence of the art museum, a nineteenth-century invention, came into being as the institutional surplus of the ambitions of empire.

6 Chihuly's turning the glass container inside out repositions the glass not only as the "inside," but also, of course, as the commodity itself.

7 Capability Brown, the leading exponent of the eighteenth-century English landscape movement under George III, declared: "Placemaking and a good English garden depend entirely on principle and have little to do with fashion."

8 "Kew was essential to the developing Empire," the current guidebook reads, "supplying seed, crops, and horticultural advice to colonies."

9 Of course, there are different types of *mises-en-abyme*, with varying degrees of complexity. One of the commonly recognizable (and simple) forms is the Salvation Army logo, consisting of a shield (or logo) within a shield within a shield (or logo). For a thorough analysis of *mise-en-abyme* structure, see Lucien Dallenbach's *The Mirror in the Text* (Chicago: University of Chicago Press, 1989), trans. Jeremy Whitley.

For generously sharing his many insights about Dale Chihuly's work, so different from the catalog of received ideas about the artist, I am particularly grateful to Barry Rosen. I would also like to thank Joe Cronin for his helpful comments after reading an early version of this essay and also Phil McCracken, as always, for filling in the blanks.

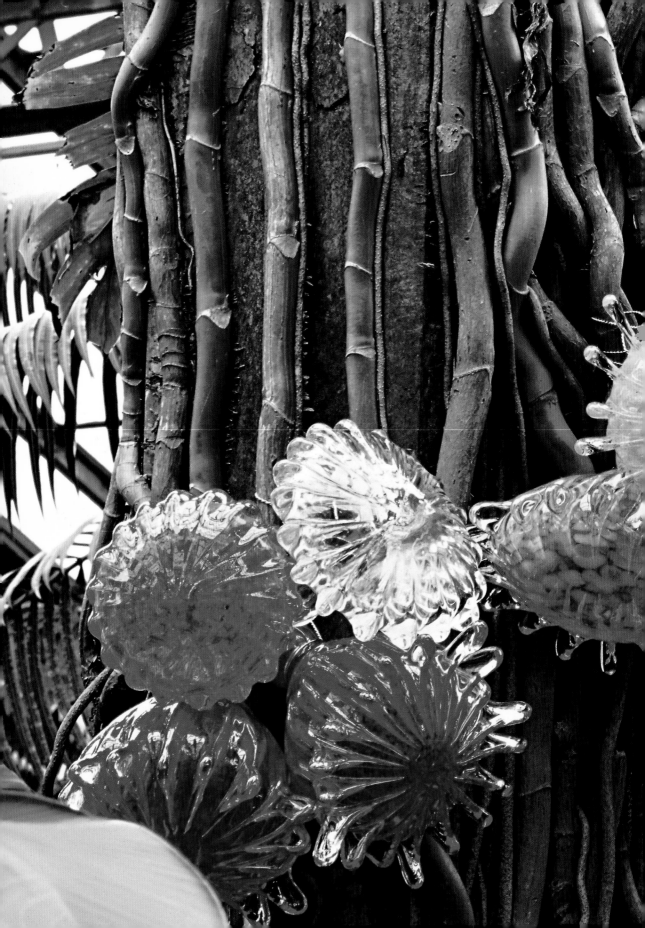

GARDENS

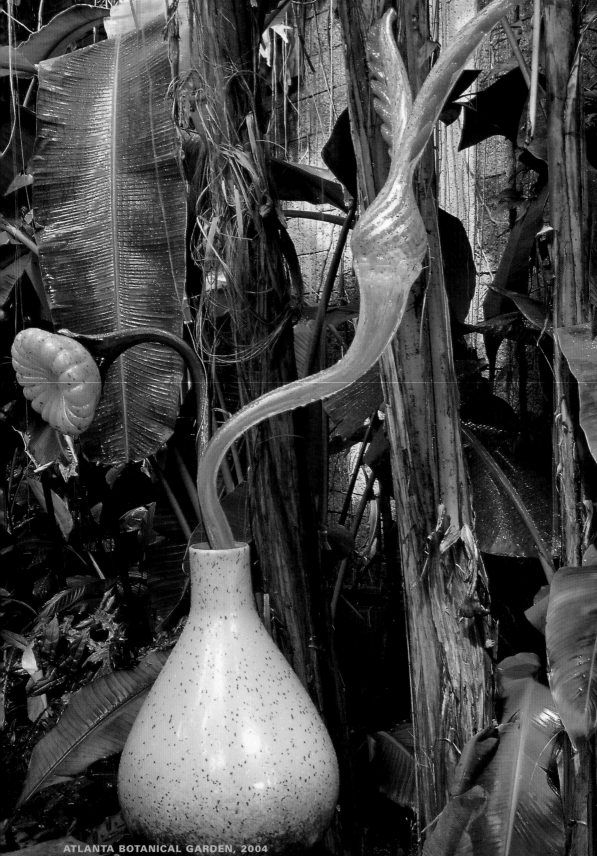

ATLANTA BOTANICAL GARDEN, 2004

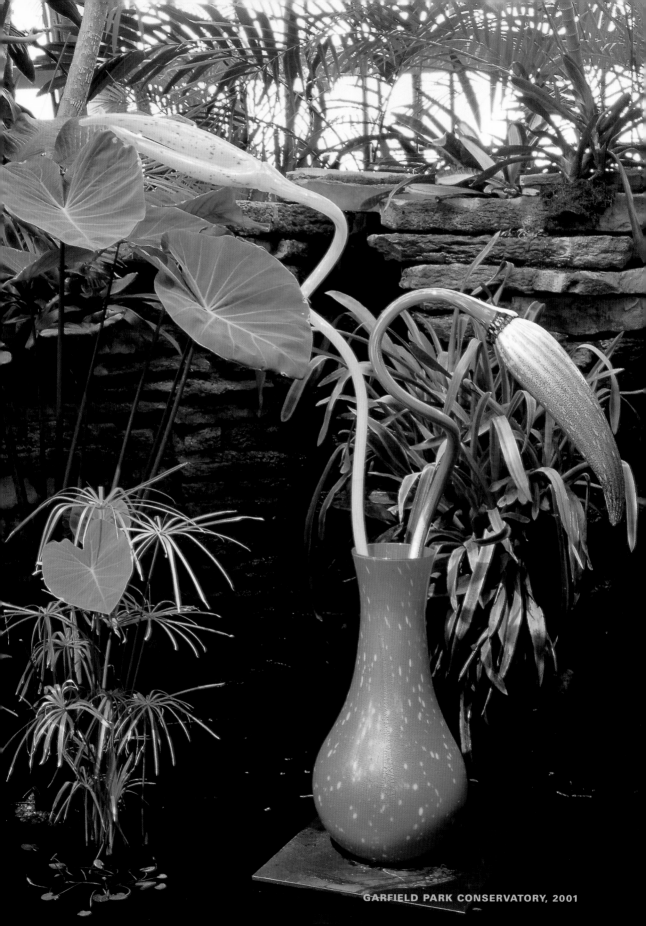

GARFIELD PARK CONSERVATORY, 2001

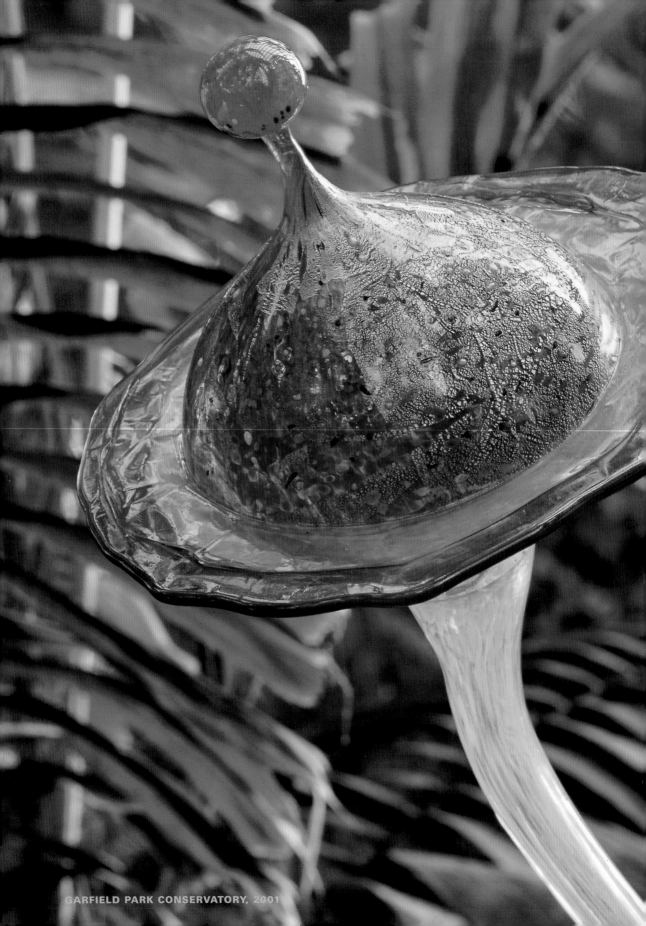

GARFIELD PARK CONSERVATORY, 2001

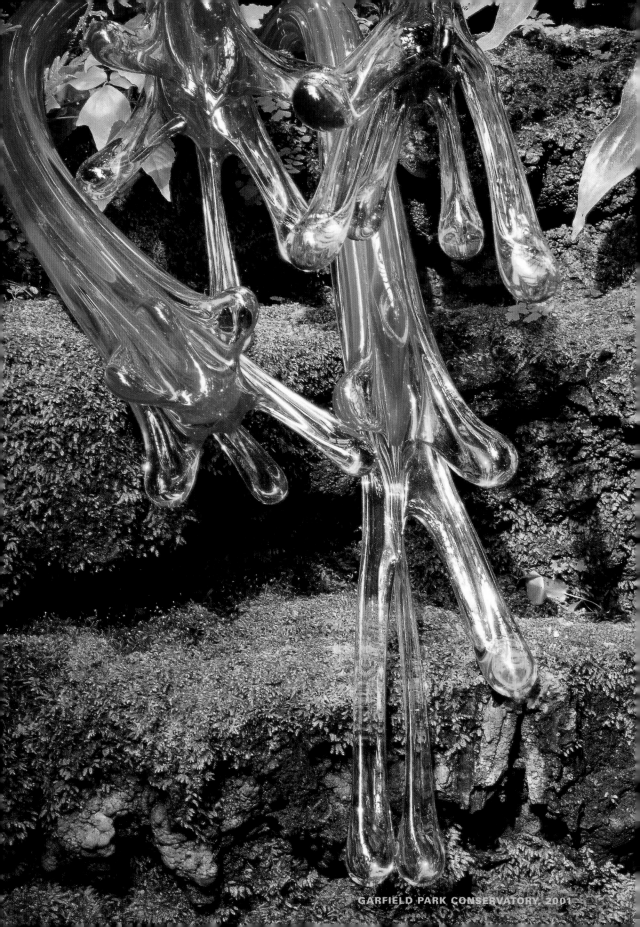

GARFIELD PARK CONSERVATORY, 2001

GARFIELD PARK CONSERVATORY, 2001

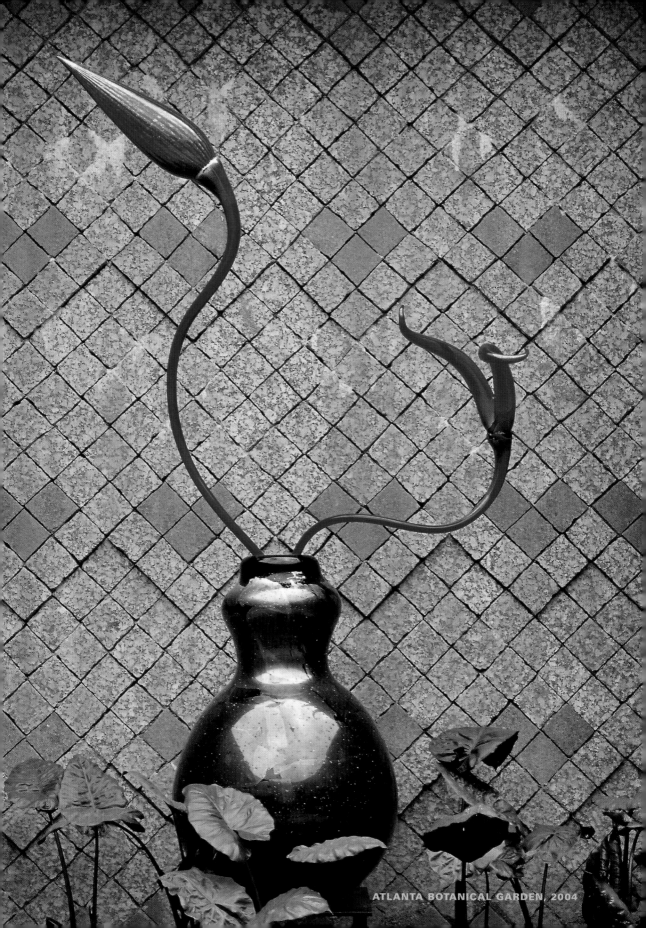

ATLANTA BOTANICAL GARDEN, 2004

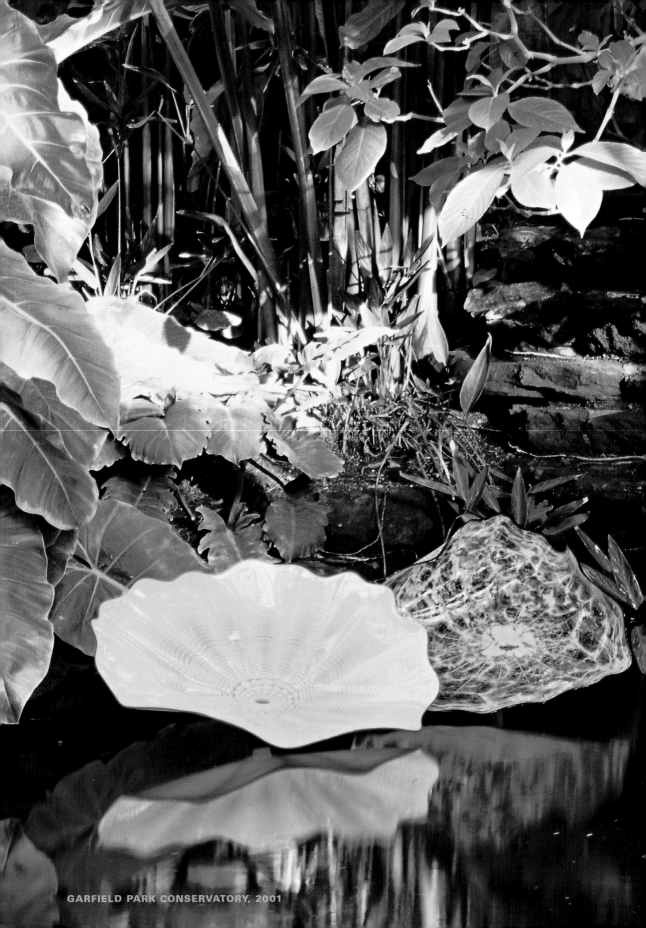
GARFIELD PARK CONSERVATORY, 2001

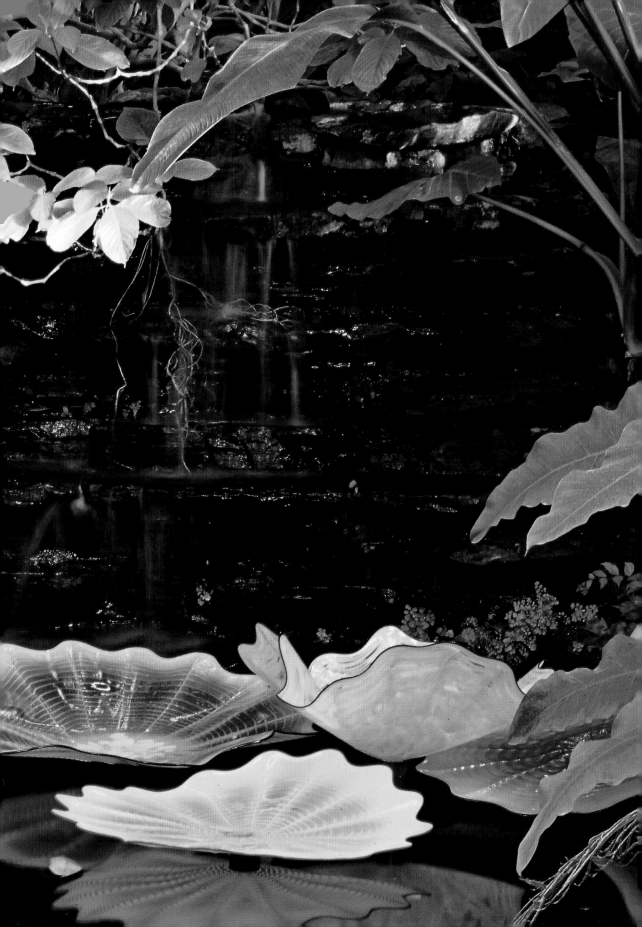

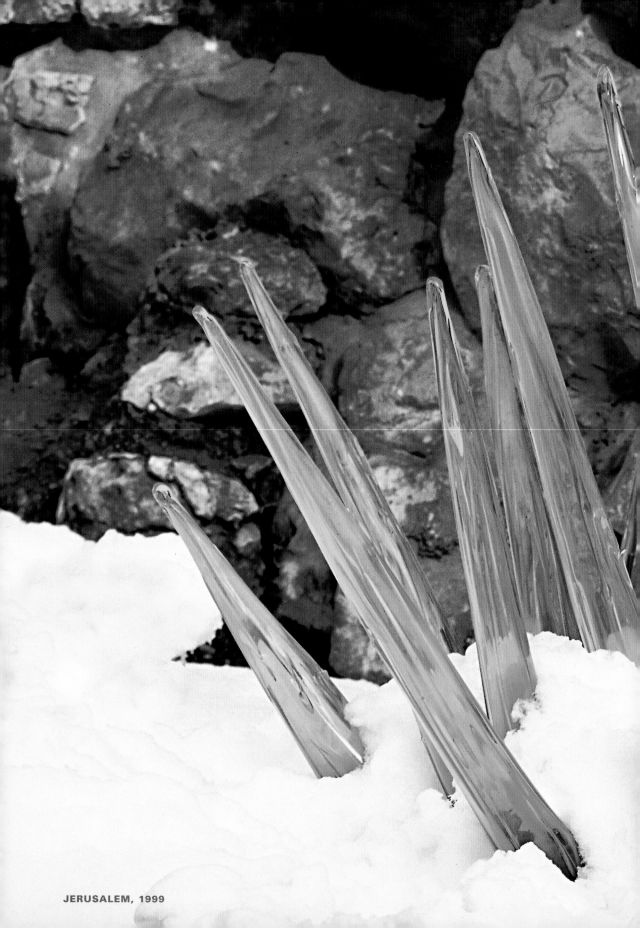

JERUSALEM, 1999

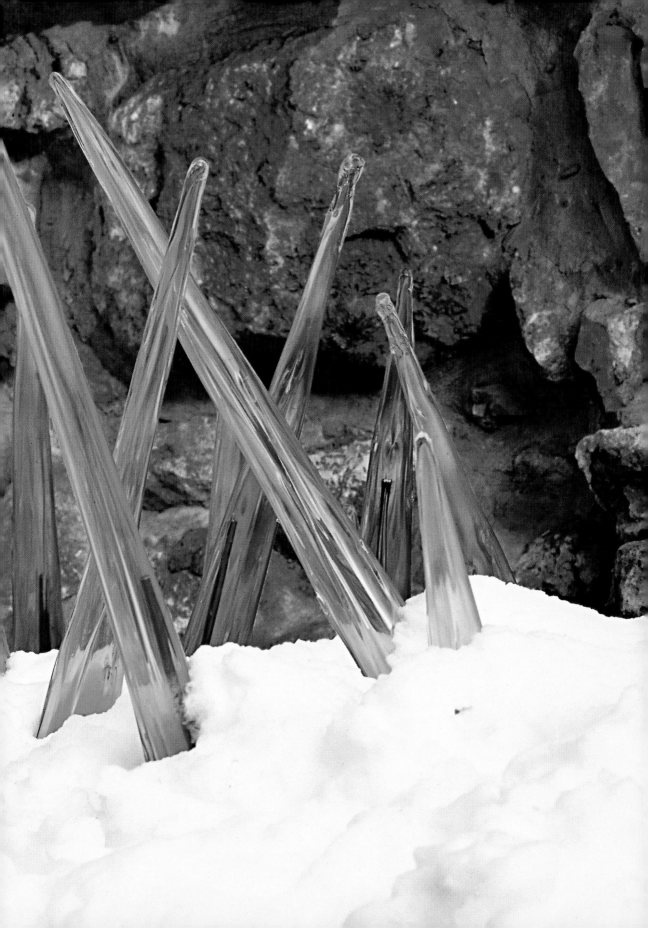

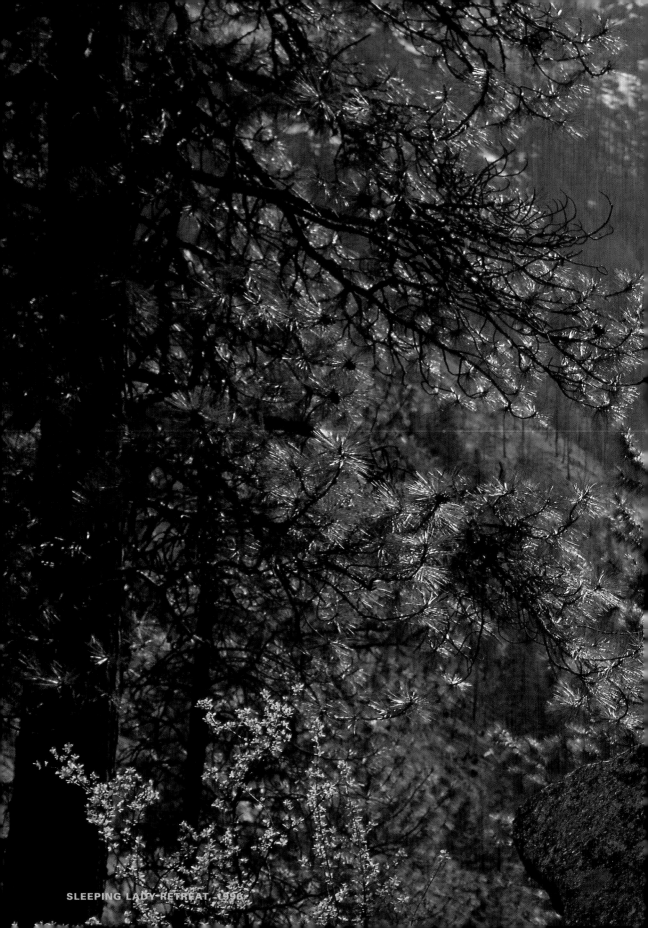

SLEEPING LADY RETREAT, 1996

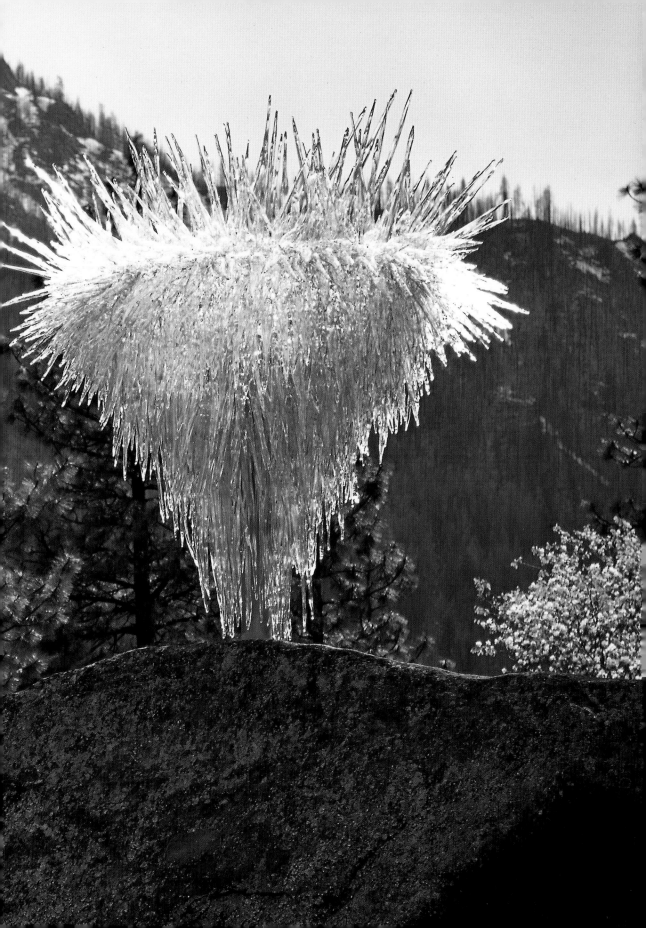

GARFIELD PARK CONSERVATORY, 2001

GARFIELD PARK CONSERVATORY, 2001

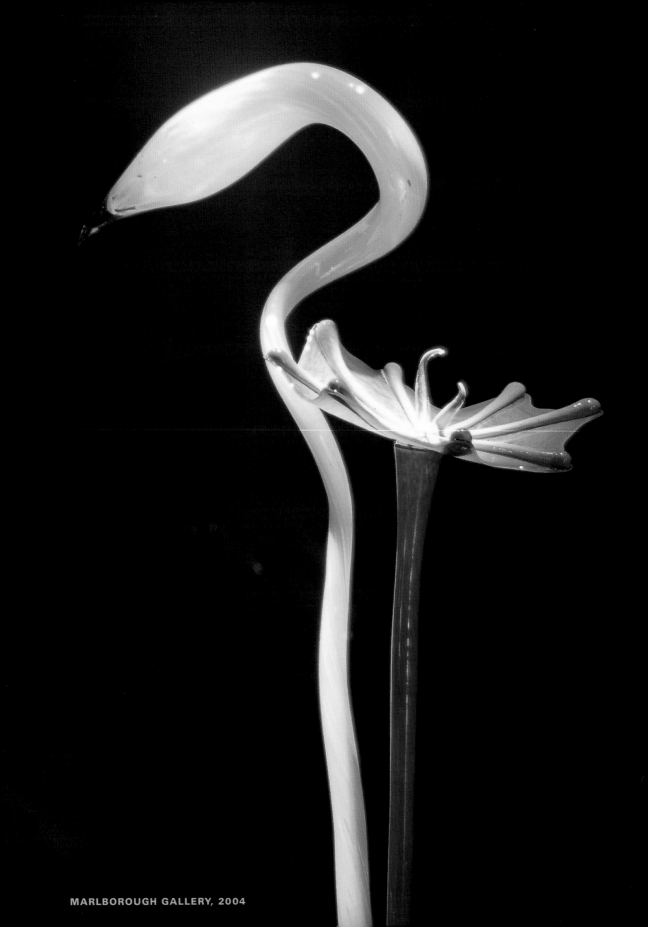

MARLBOROUGH GALLERY, 2004

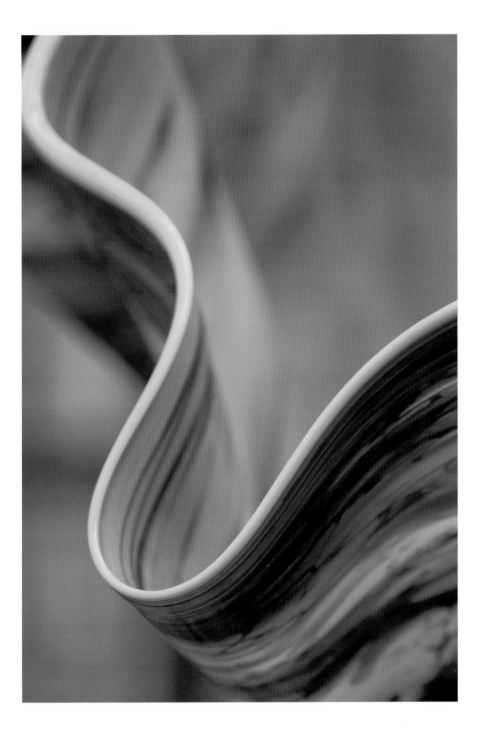

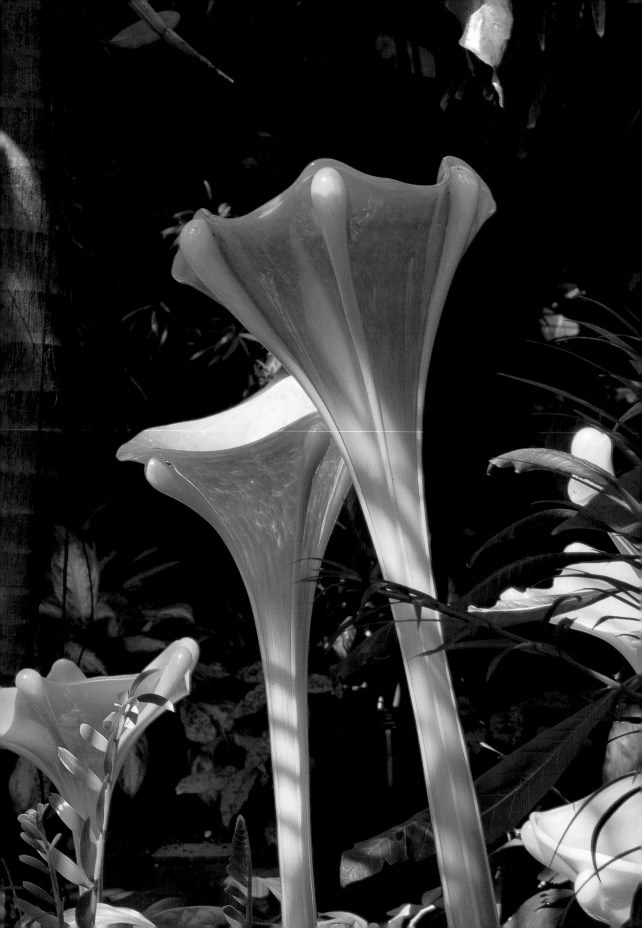

ATLANTA BOTANICAL GARDEN, 2004

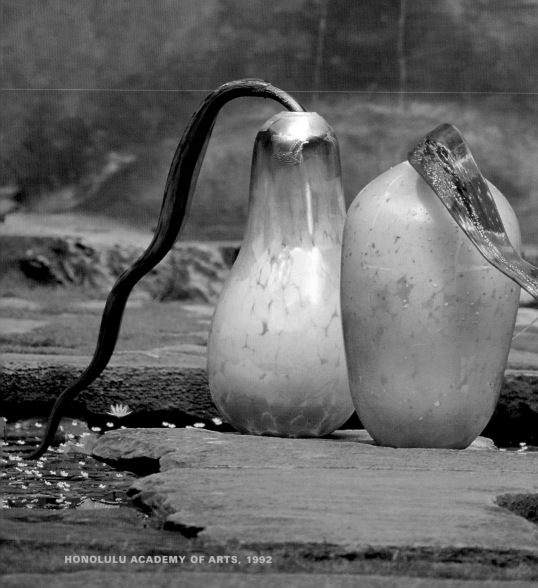

ATLANTA BOTANICAL GARDEN, 2004

ed Arenga Palm
ena caudata
Those
Thailand, Burma

FRANKLIN PARK CONSERVATORY, 2003

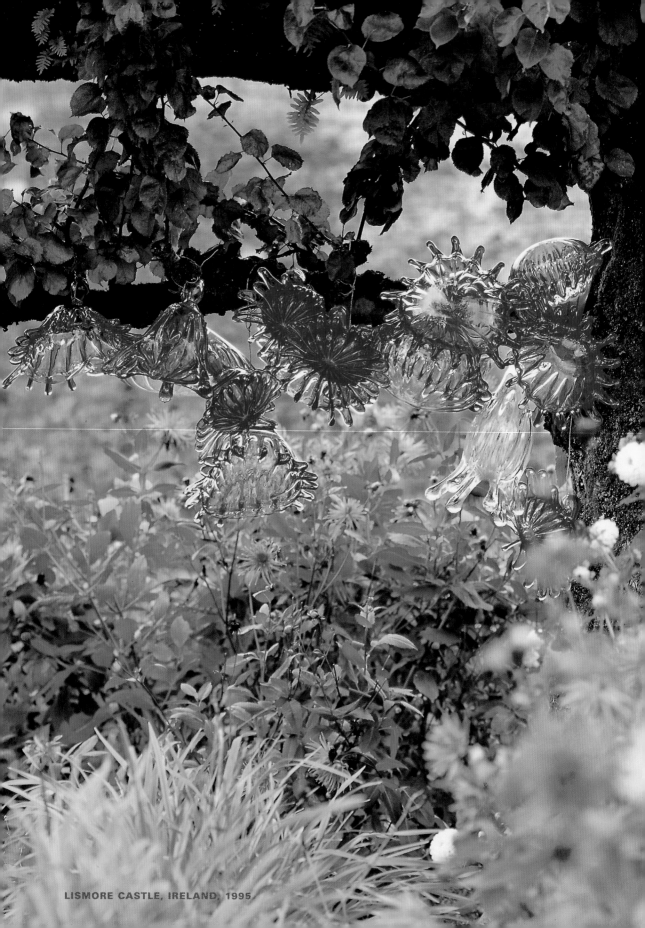

LISMORE CASTLE, IRELAND, 1995

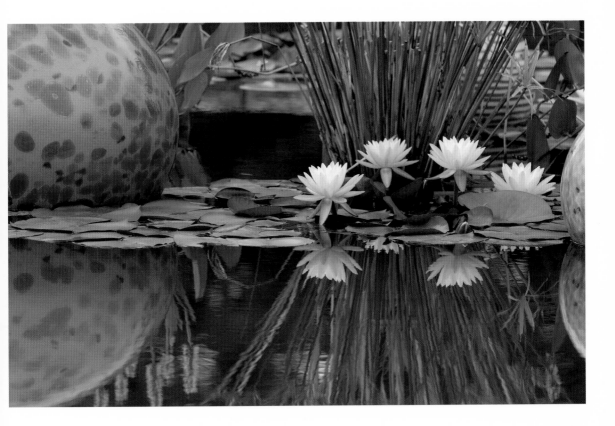

ATLANTA BOTANICAL GARDEN, 2004

GARFIELD PARK CONSERVATORY, 2001

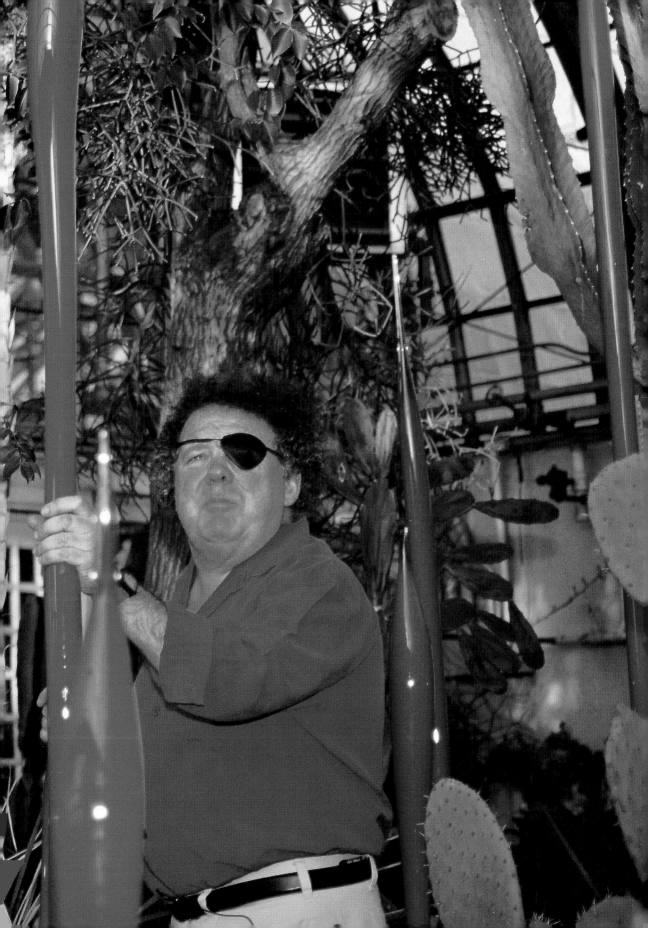

ATLANTA BOTANICAL GARDEN, 2004

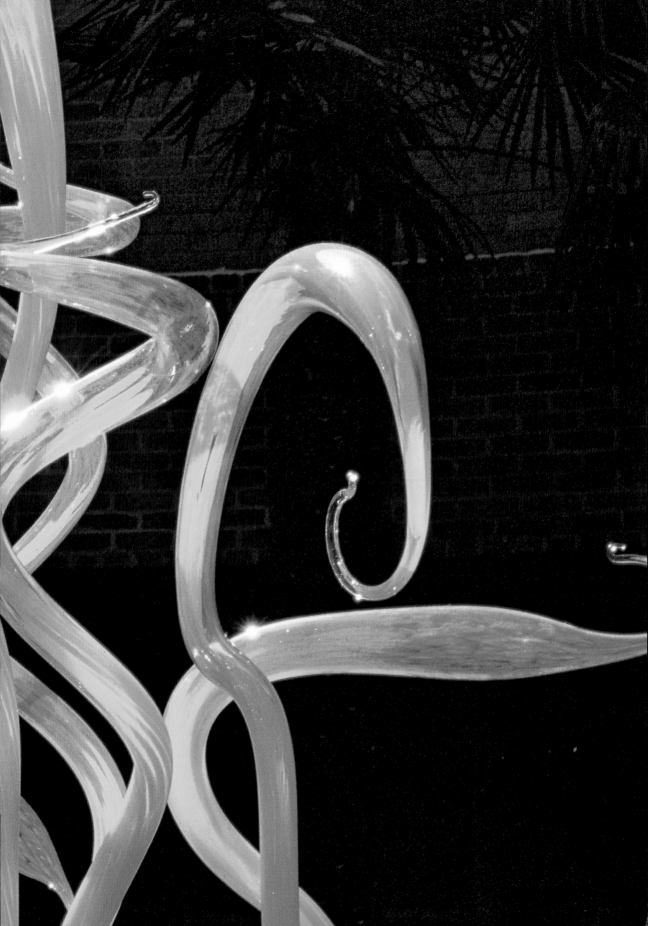

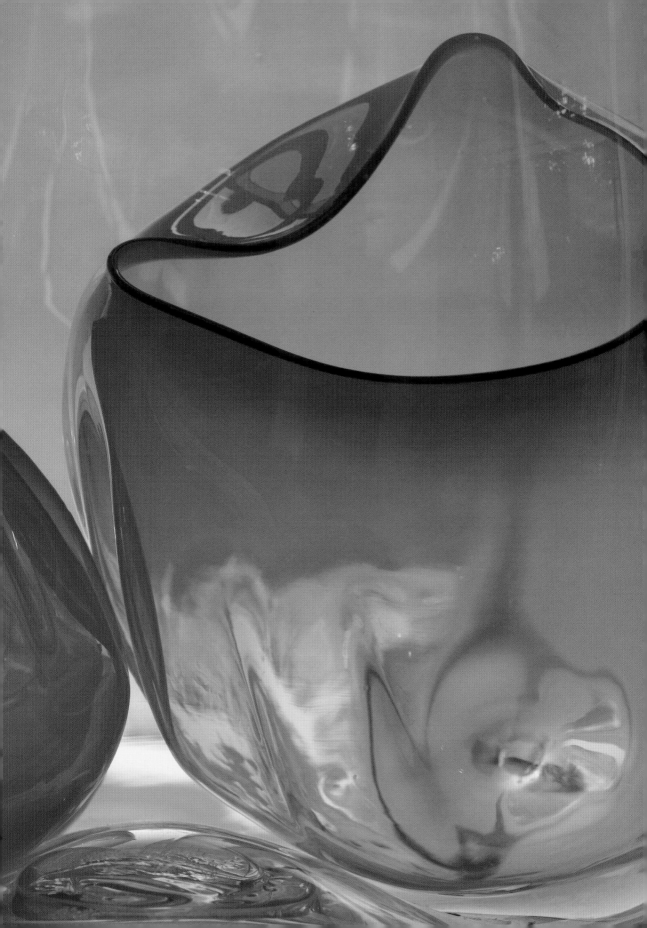

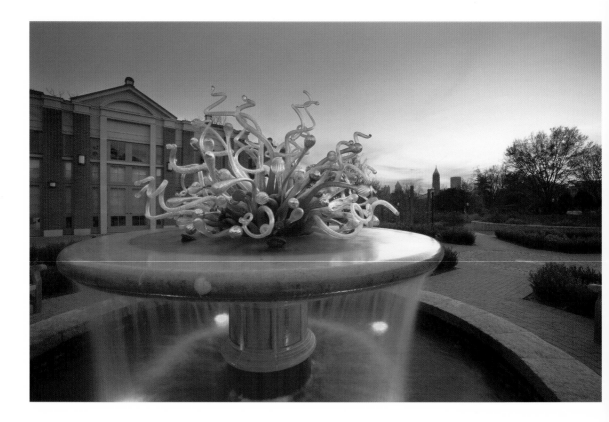

ATLANTA BOTANICAL GARDEN, 2004

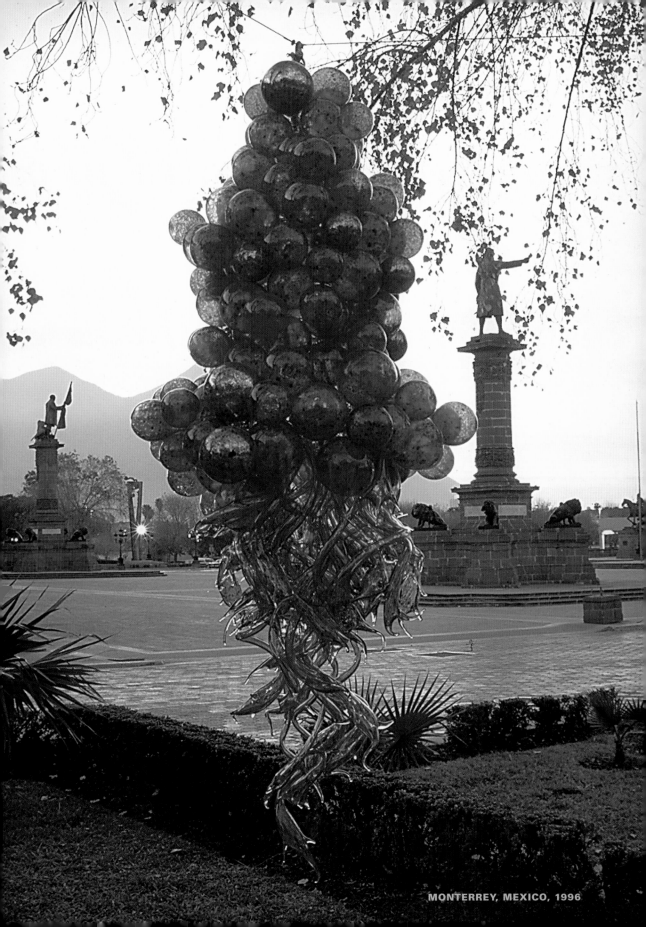

MONTERREY, MEXICO, 1996

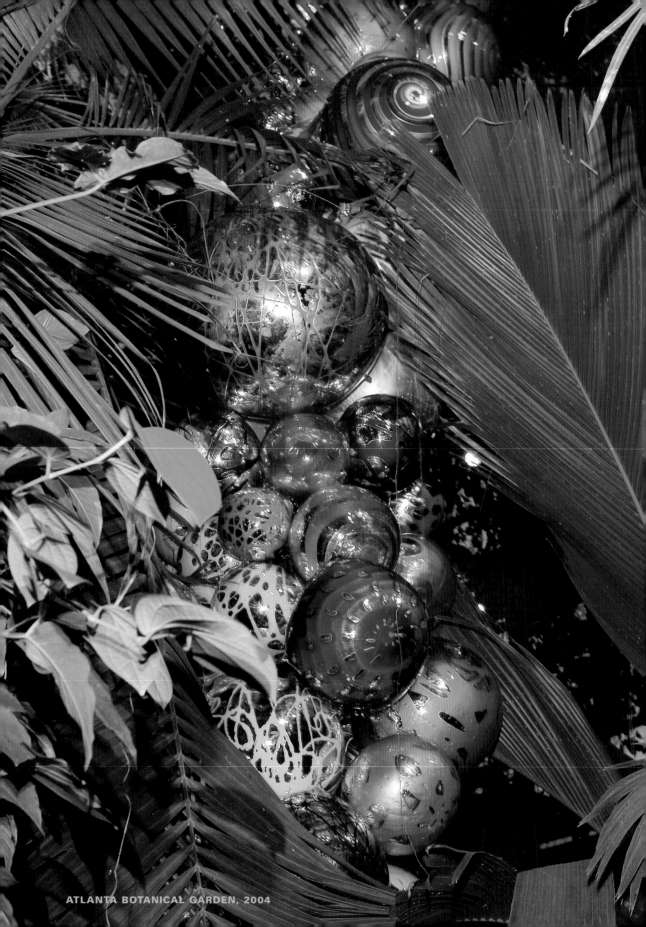

ATLANTA BOTANICAL GARDEN, 2004

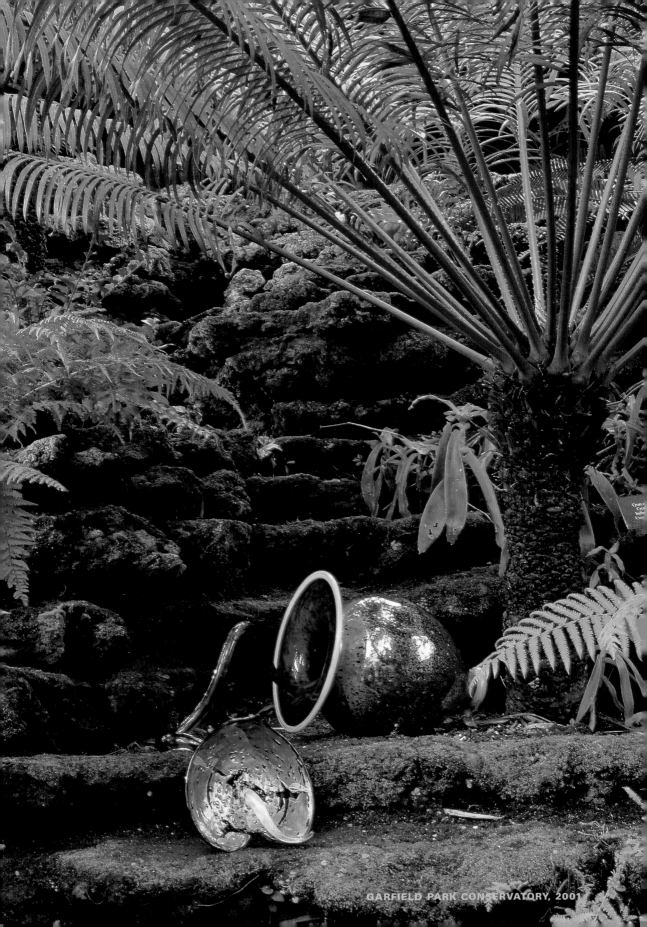

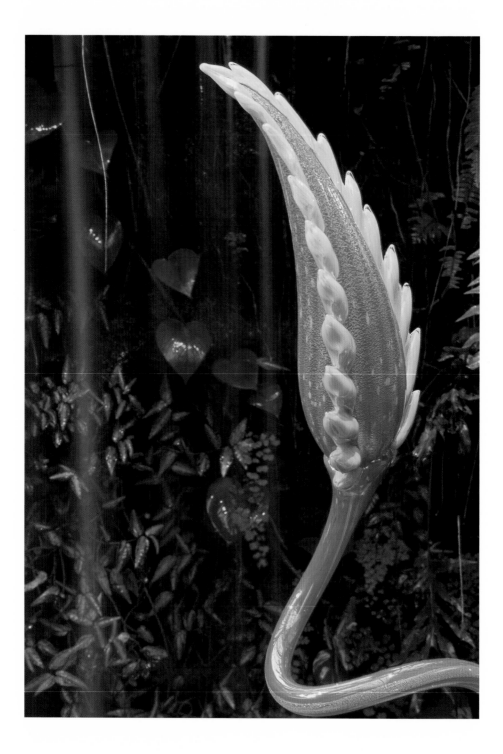

ATLANTA BOTANICAL GARDEN, 2004

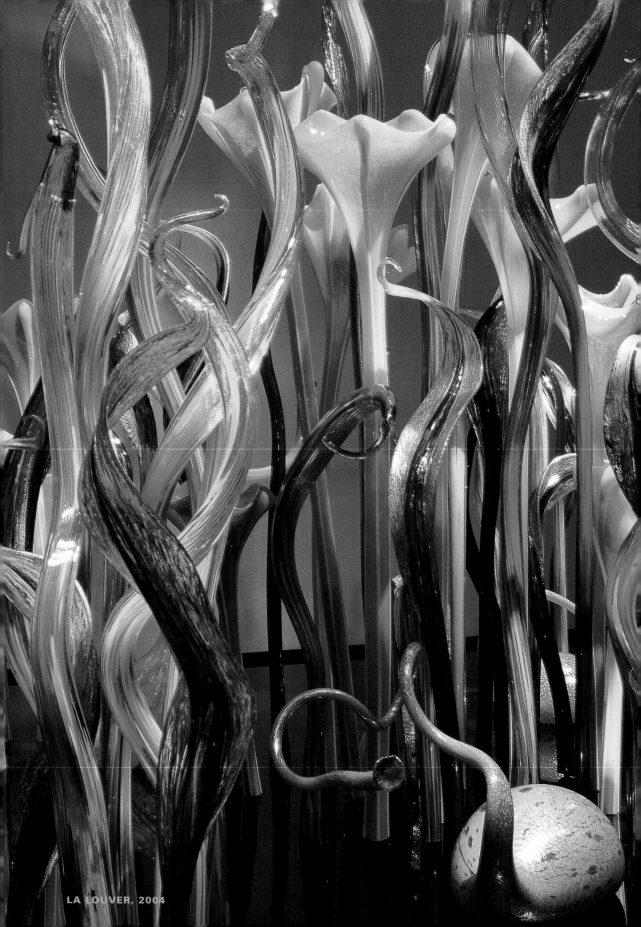

LA LOUVER, 2004

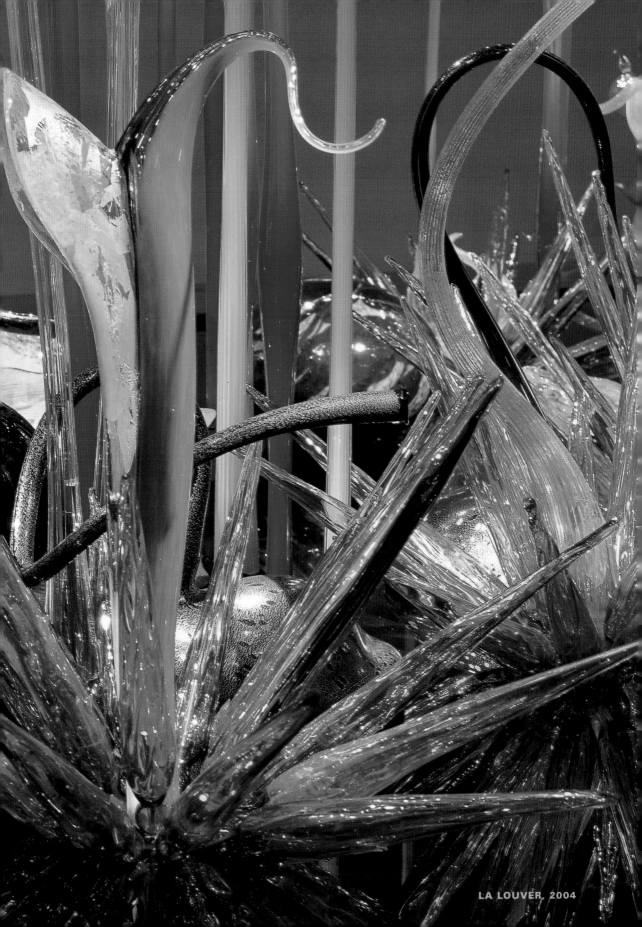

LA LOUVER, 2004

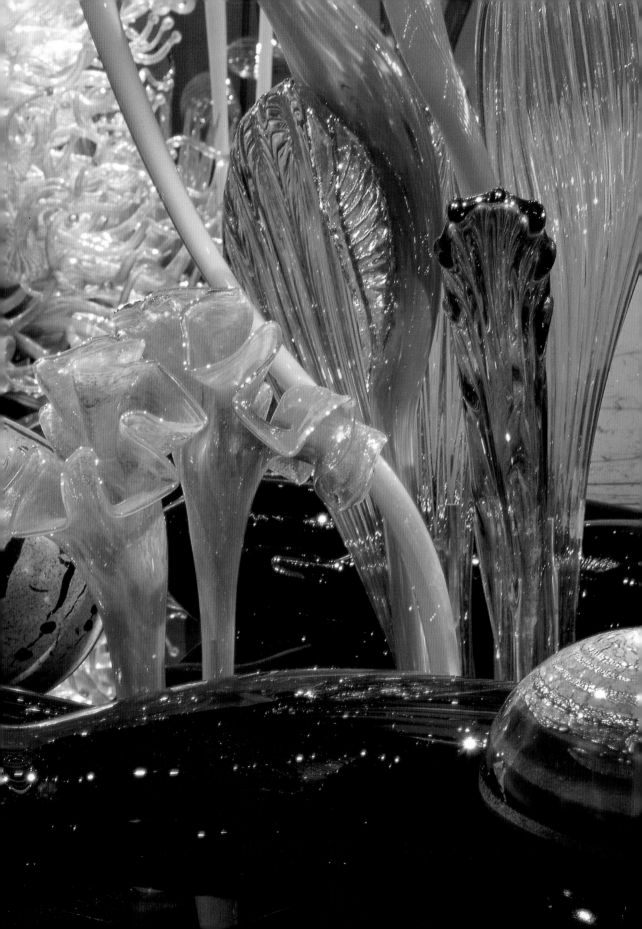

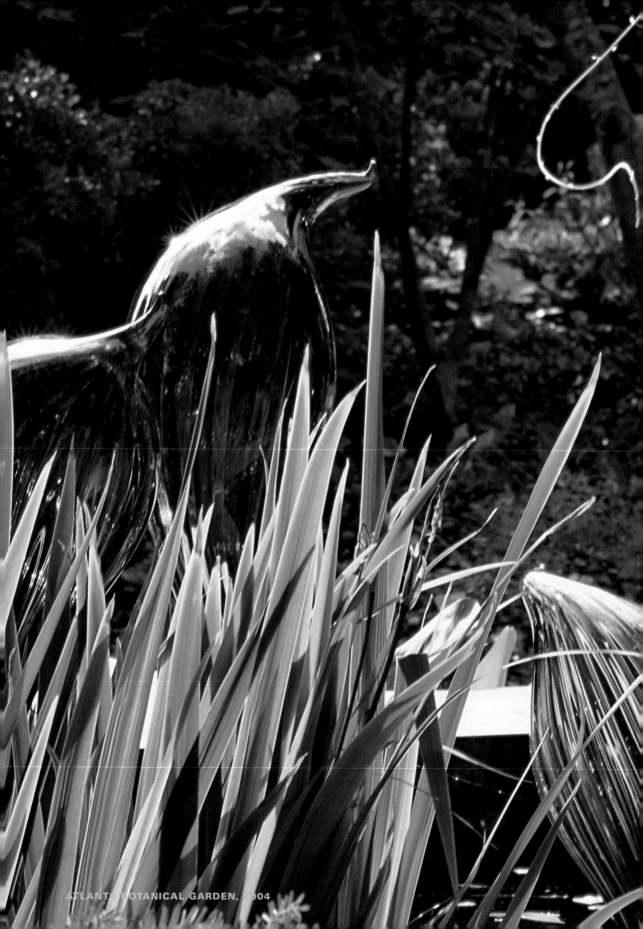

ATLANTA BOTANICAL GARDEN, 2004

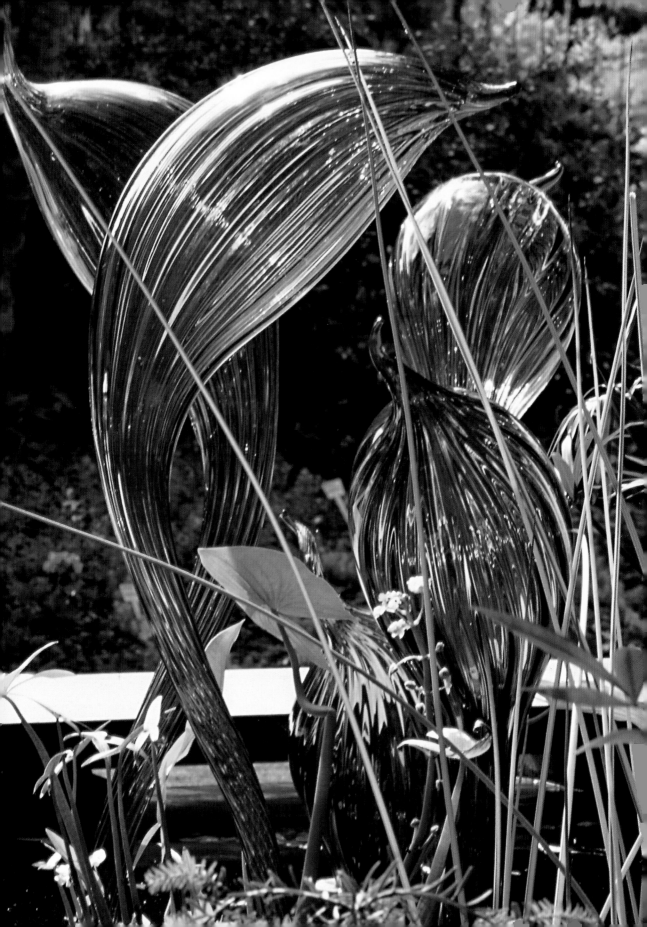

THE PALM HOUSE AND SUMMER BEDDING AT KEW GARDENS

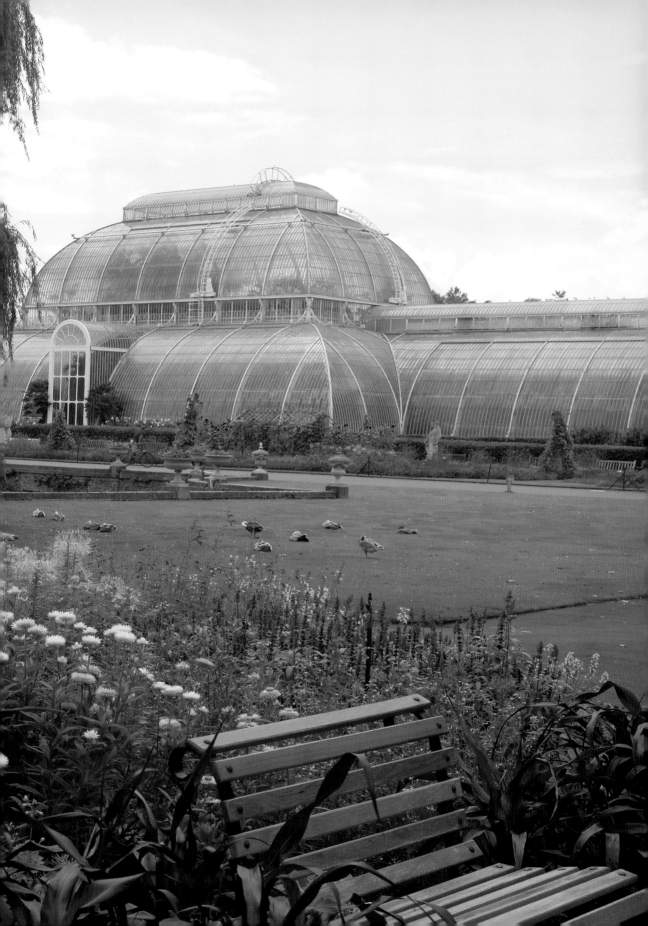

THE HISTORY OF THE
ROYAL BOTANIC GARDENS, KEW

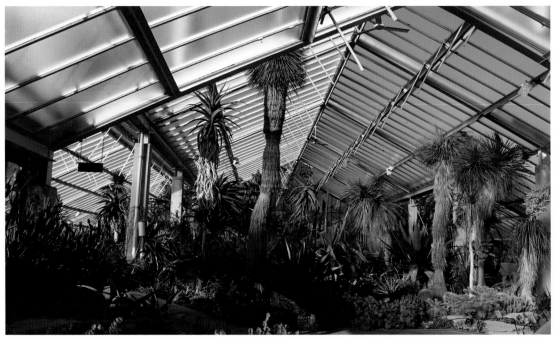

The dry tropic zone in the Princess of Wales Conservatory

The history of the Royal Botanic Gardens, Kew is an equally and a richly woven, intricate tapestry. It is not the result of one creative initiative or person. What we see today is the result of layer upon layer of innovative effort, adaptation, change, additions, and losses. The traces of this evolution are part of the present-day character and spirit of the place. They provide vital clues that can help us to understand what Kew was like in the past, how it has taken on its present form, and even where it might go in the future.

There had been a palace at Richmond from the Middle Ages until the death of Charles I in 1649. Shortly after this its demolition began, but the palace lands survived the Commonwealth of Oliver Cromwell and continued to provide members of the royal family with homes into the eighteenth century. It is from the gardens of two of these homes, Richmond Lodge and the White House, that the present Royal Botanic Gardens have been largely formed.

Richmond Lodge was in what is now the Old Deer Park. From 1718 it was a residence of the Prince and Princess of Wales, the future George II and Queen Caroline. Caroline took in hand the laying out of the Richmond Gardens, and engaged Charles Bridgeman and William Kent to help.

Both are famous and honoured names in gardening history. The former was a master of the English Grand Manner. His work and ideas made a very important contribution to the development of the English naturalistic style of landscaping. He enjoyed the position of Royal Gardener to George II and Queen Caroline. William Kent was one of the foremost architects and designers of his day. He also became a landscape gardener and is usually credited with the introduction of the naturalistic English style.

Caroline and George's son Frederick, Prince of Wales, leased a house at Kew in 1731 which came to be known as the White House. Its proximity to Richmond Lodge might have signified happy relationships within the royal family, but Queen Caroline loathed her son and so did the king. Family animosities apart, it was for the White House that Frederick and his wife, Augusta, created what became known as Kew Gardens. After Frederick's death in 1751, Augusta continued his work with the help of a close friend, John Stuart, 3rd Earl of Bute, a statesman and horticulturist, and of the architect Sir William Chambers. As part of her Kew Gardens, the princess created a rich botanical collection of curious and exotic plants. At the time of Princess Augusta's death in 1772, Kew Gardens and Richmond Gardens were separated by one of the most important landmarks in the history of the Royal Botanic Gardens: the mysterious and evocatively named Love Lane.

The two gardens were not only separate, they were also very different in style. Kew Gardens was essentially naturalistic with a light and fanciful character in the spirit of the English Rococo. It was a long, open space divided into three great lawns and a lake, with an ornamented walk around its perimeter. This passed through a large pleasure ground with ornamental and exotic plants, and continued past a series of classical and exotic garden buildings, which included the Pagoda.

George III, son of Prince Frederick and Princess Augusta, came to the throne in 1760. Richmond Lodge and later the White House became his summer retreat. He engaged one of the most famous landscape gardeners of all time, Lancelot 'Capability' Brown, to prepare a scheme for a new landscape that would take in the whole of Richmond Gardens. In the end, only the northern part of Brown's proposal was executed.

Although naturalistic in style, Brown's work at Richmond Gardens

was of a very different character from Princess Augusta's Kew Gardens. In Brown's design the main space flows around a large central block of woodland. Thick perimeter plantations formed its boundaries on three sides, and the fourth was open to the River Thames and the landscape beyond. The design for Augusta's gardens was bold, but Brown's design for Richmond Gardens was much bolder: the variety of shapes and spaces was greater, the lines of the walks and drives were more varied, and the style was slower and grander. He concentrated on using natural elements to emphasize abstract qualities such as space, form, texture, and an overall integration of character; it was not peppered with ornamental and exotic buildings. The whole design was much less artificial in character than Kew Gardens. In this way it fills the mind with a sense of the simple nobility and beauty of nature.

Sir William Chambers and Capability Brown did not see eye to eye on the question of garden and landscape design. So it is more than a little ironic that the present Royal Botanic Gardens are the result of joining the two areas where they had worked. The first step came when Princess Augusta died. By 1784 there was a wooden bridge over Love Lane to link Kew Gardens and Richmond Gardens at a point close to the White House. The full union of the two gardens was not achieved until 1802, when Love Lane was removed.

The White House was demolished the same year, by order of George III, because he wanted to build an imposing palace closer to the river. Although most of Augusta's Kew Gardens have now disappeared, some important elements survive. Two of these, the Orangery and the Pagoda, help us to appreciate the distance from one end of the gardens to the other.

It was thanks to George III that Sir Joseph Banks became closely associated with Kew Gardens. Banks was introduced to the king, and by 1773 he had 'a kind of superintendence' over the gardens as informal 'director.' This led to Kew becoming primarily a botanic garden, receiving plants from around the world. It was also during George III's reign—in about 1776—that the gardens first opened to the public.

Sir William Jackson Hooker was appointed director in 1841. He engaged William Andrews Nesfield, the landscape gardener, to advise on some very important alterations to the general layout of the Royal Botanic

Leaves of the giant waterlily Victoria 'Longwood Hybrid' in the Princess of Wales Conservatory

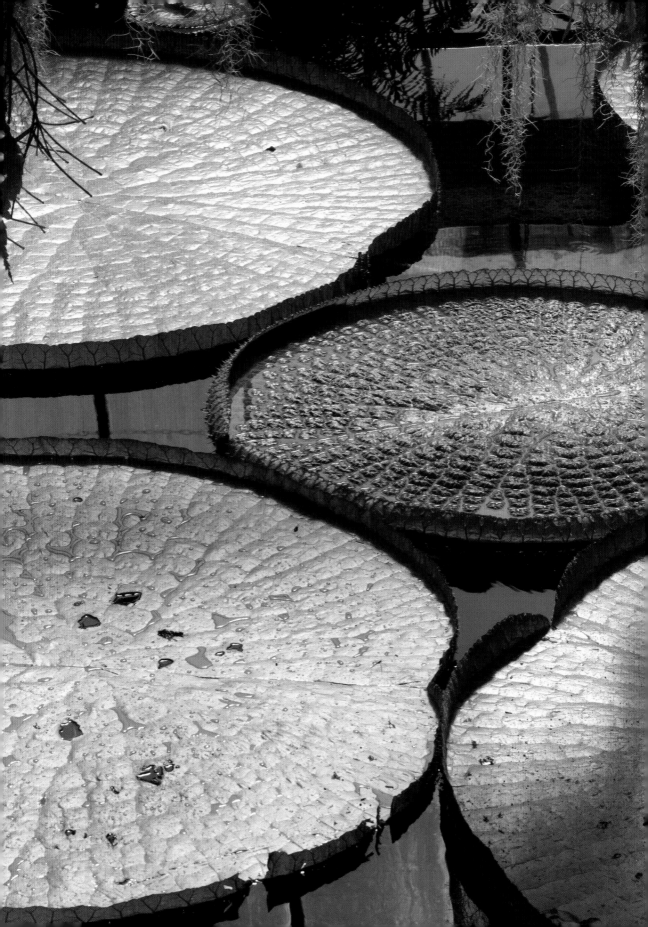

One of the 'old lions', *Robinia pseudoacacia,* near the Orangery

Gardens. The purpose of Nesfield's designs of 1843–48 was to improve public access and circulation around the Royal Botanic Gardens by linking a new main entrance at Kew Green to a new Palm House and a new Arboretum. The Palm House was in what had been Princess Augusta's Kew Gardens, and the Arboretum spread over the northern part of the former Richmond Gardens and the southern part of the former Kew Gardens. Nesfield prepared a scheme for the Arboretum and introduced the straight lines of the Broadwalk as well as the geometric layout around the Pond and Palm House. This provided a strong formal core to the otherwise naturalistic design.

The changes that took place in the 1840s were not the last and, of course, there have been many others since. William Hooker's son, Joseph, who became the second director at Kew, overhauled the Arboretum, added the Cedar Vista, and redesigned the original lake. Slowly the landscape has changed in keeping with fashions and in responding to the development needs of the Gardens. Keynote buildings like the Temperate House and the Princess of Wales Conservatory have been added. However, throughout all these changes, the key structural

elements of Nesfield's design and other features from earlier work have survived and continue to play a dominant role in the character of the landscape.

The Palm House, built between 1844 and 1848, is one of the finest surviving nineteenth-century glasshouses. At the time it was the largest glasshouse in the world. Decimus Burton, the Royal Botanic Gardens' architect, was responsible for overseeing the building. Although he was officially the architect and is generally credited with the design, it was Richard Turner who developed the structural solutions that made possible the fifteen-meter (nearly fifty-foot) wrought-iron spans to be built.

The structure's functional lines and elegant restrained shape contrast with the more exuberant and frivolous wrought-ironwork decoration that adorns the internal pillars, staircases, and arches. This reflects the differing characters of Turner and Burton, with Turner being responsible for the decorative elements, characterised by a sunflower motif, whilst Burton preferred the clean, unadorned lines of the exterior.

Turner also designed the heating system: a series of hot-water pipes set beneath a grilled wrought-iron floor. It took twelve boilers under the floor of the Palm House to heat these. The smoke was drawn along a long flue to a chimneystack, the Campanile, which Burton designed in the form of an Italianate bell tower.

The Palm House was originally glazed in glass in a pea-green tint. This was thought to provide the best light conditions for the plants, but as atmospheric pollution intensified in the late nineteenth century, the glass was gradually exchanged by Sir William Thiselton-Dyer, the third director of Kew, for a clear variety.

Decimus Burton designed the Temperate House in 1859. It is the world's largest surviving Victorian glasshouse, with a floor area of 4,880 square meters (more than 50,000 square feet). The building is made up of three elements: a centre section and two octagons, built between 1859 and 1862, plus two wings not completed until 1899. It is more rectangular in form than the Palm House, built this way primarily to reduce the expense, however, the central section and octagons still cost three times more than the original estimate of £10,000.

This glasshouse was built to house tender woody plants from the world's temperate regions. The current collections are still laid out in the original geographical manner envisaged by

Burton, and they include plants from Africa, the Mediterranean, Australasia, and Asia. One of the most famous specimens is the Chilean Wine Palm, believed to be the world's largest indoor plant.

The Princess of Wales Conservatory is the largest modern glasshouse at Kew, combining computer-monitored climate control with exceptional energy efficiency to create ten individual climatic zones. Named after Princess Augusta, it was officially opened by Diana, Princess of Wales, in 1987, and has won numerous awards.

The building was constructed on the site of twenty-six dilapidated glasshouses. Designed by Gordon Wilson to blend with the historic landscape, it creates an architectural statement as powerful as that made by the earlier glasshouses. It has set the standard for other large botanic greenhouses across the United Kingdom, including the National Botanic Gardens of Wales and the Eden Project in Cornwall. However, what differentiates the Princess of Wales Conservatory from the other large greenhouses at Kew is the manner in which the plants, not the architecture, dominate the interior, very much reflecting the current conservation ethic of Kew.

The new Alpine House is an elegant glass building of significant presence and unusual form. Its shape and geometry are designed to encourage the complex environmental conditions necessary for alpine growth, through passive, energy-efficient means.

The Pagoda was designed by Sir William Chambers in 1761–62 and is a splendid example of the Chinoiserie style of architecture that first emerged in Europe during the seventeenth century. Ten storeys and fifty meters (more than 160 feet) high, it dominates the southern end of the Gardens.

The original building was more ornamental and colourful than it is today. The roofs were covered with varnished iron plates, and the edge of each section had an ornamental dragon veneered with coloured glass. The Pagoda remained a key focal point in Nesfield's landscape design of the 1840s, in which he utilised its height as the terminus for the Pagoda Vista.

During the course of its history, the Royal Botanic Gardens, Kew has contributed significantly to gardening, horticultural wealth, and landscape design. But perhaps most important of all, the Gardens are a glorious manifestation of the highest levels of human achievement in relation to understanding, using, and managing plant life.

OPPOSITE The ten-storey Pagoda stands at 163 feet high
OVERLEAF A grand finale of fireworks over the Temperate House after one of the summer jazz concerts

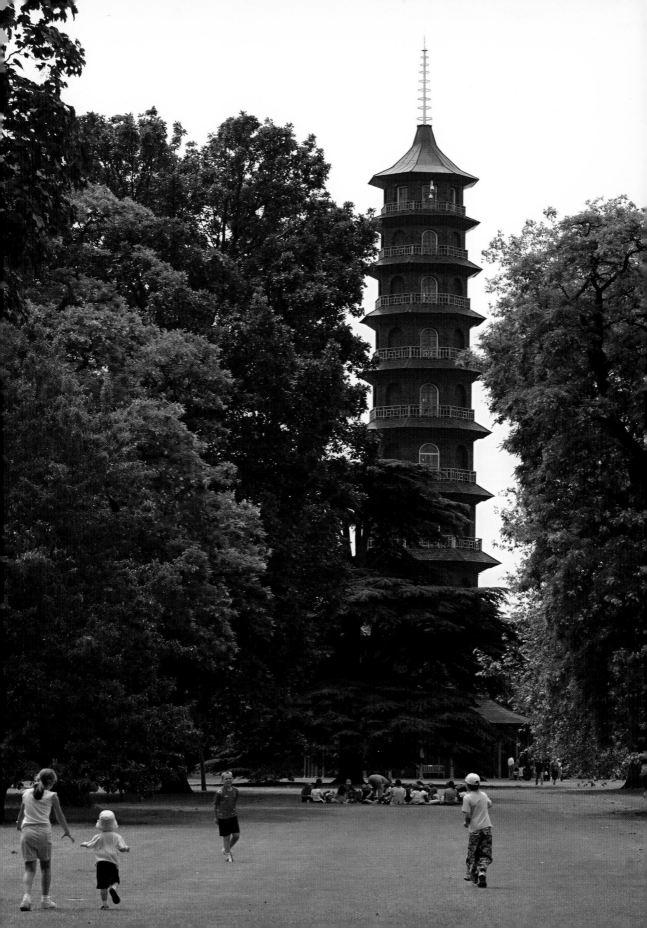

CHIHULY AT KEW

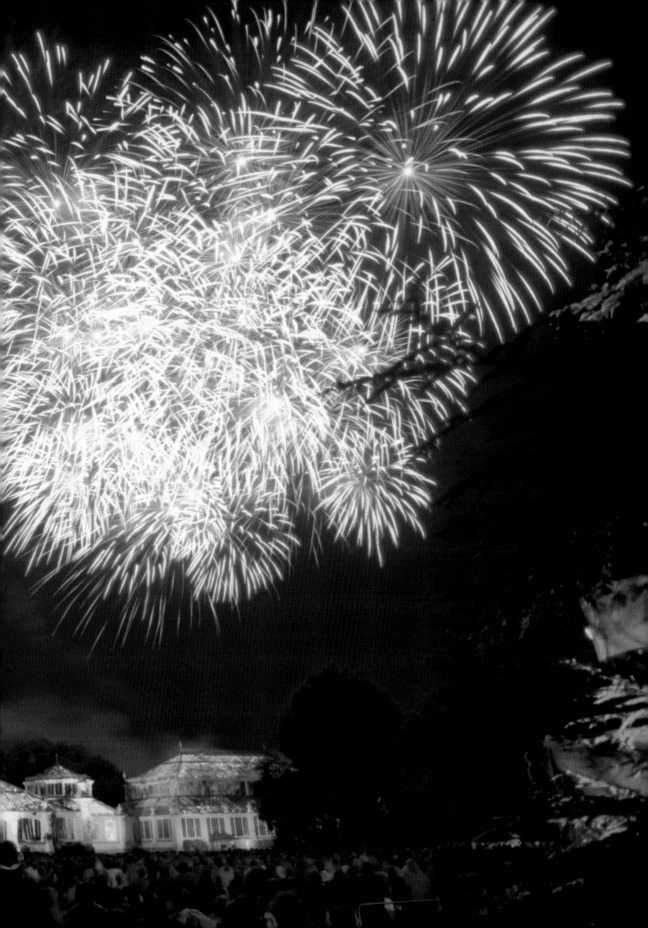

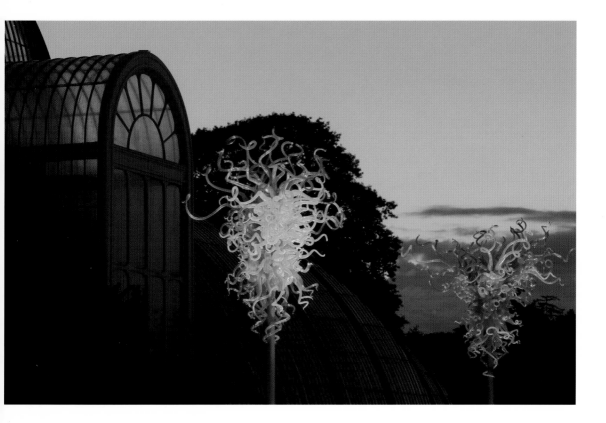

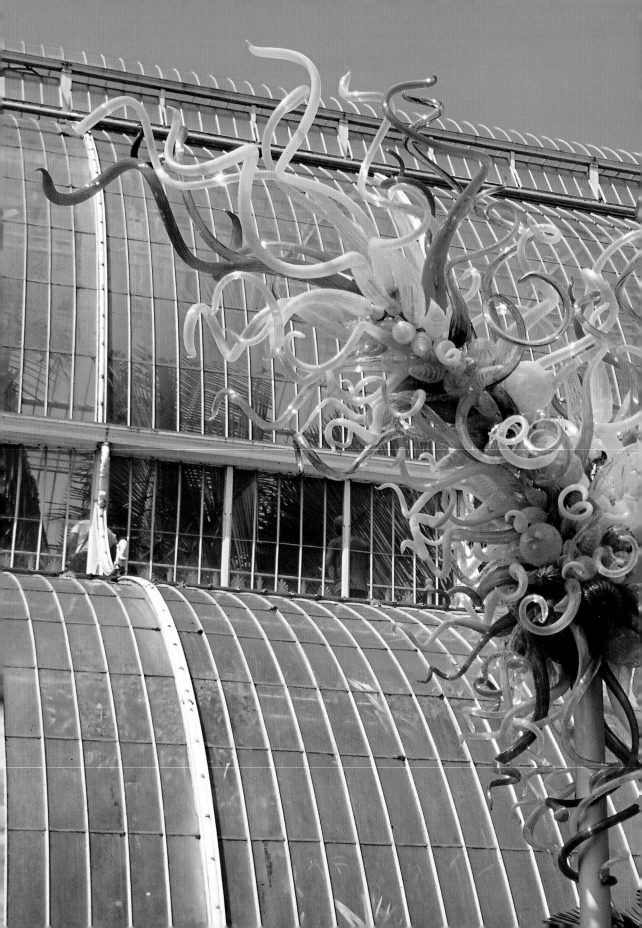

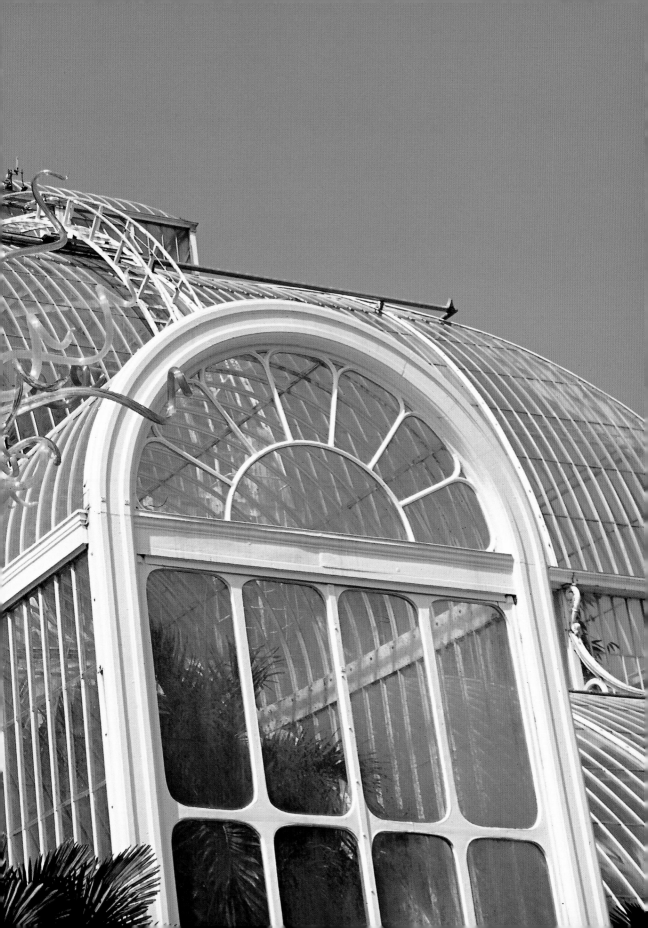

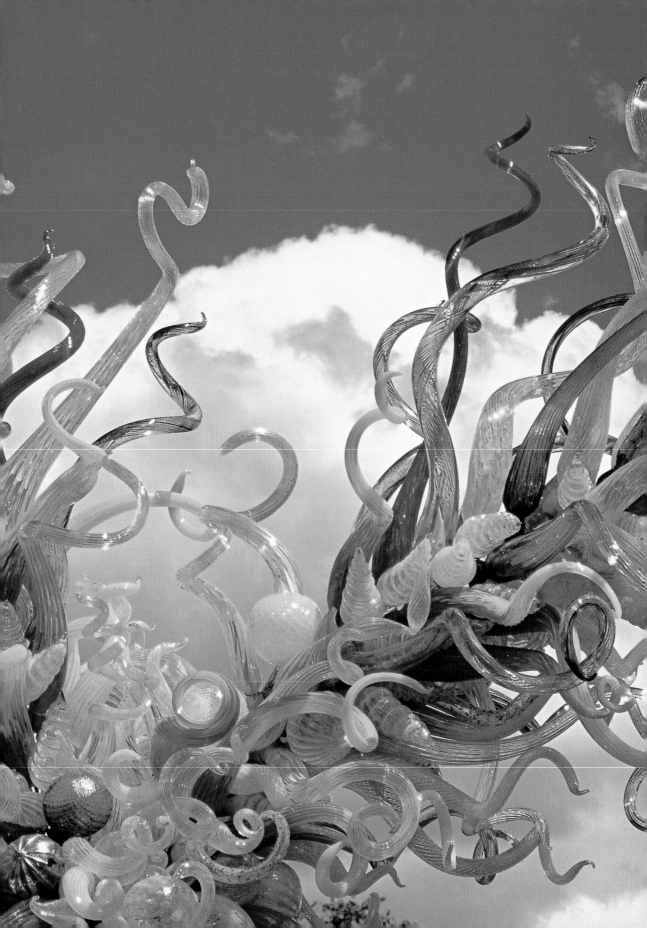

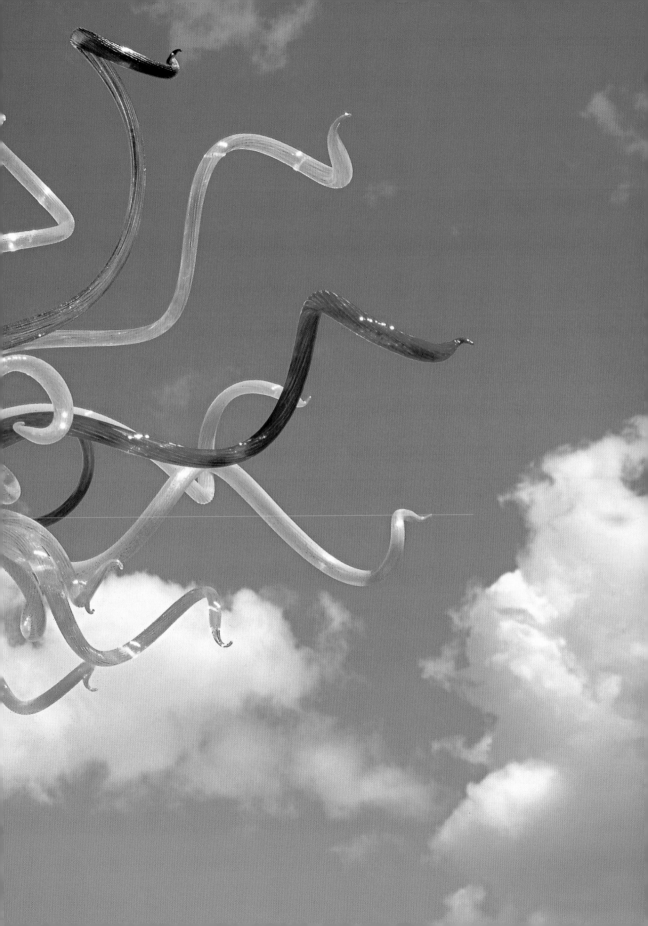

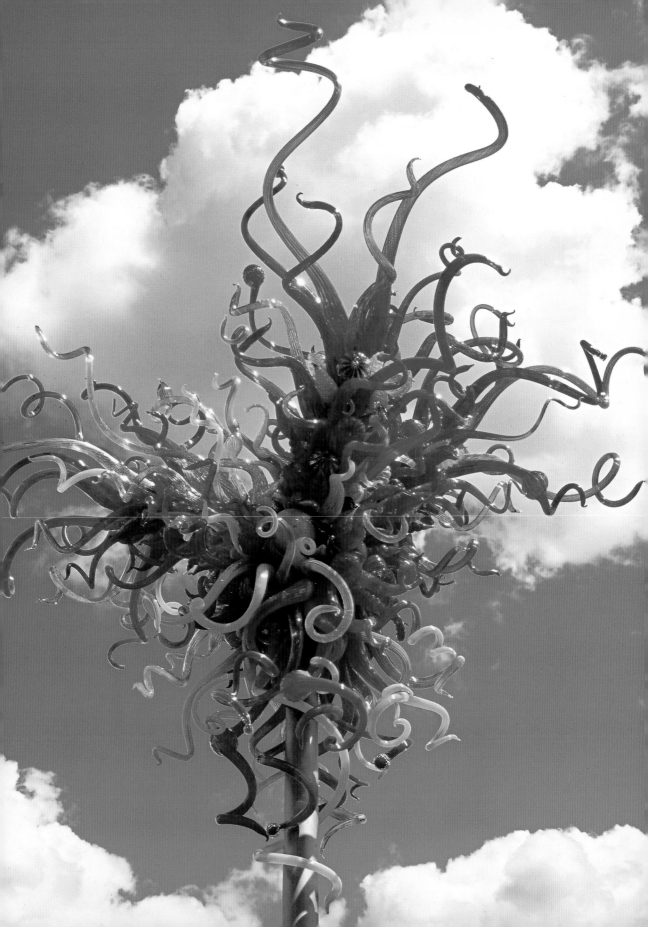

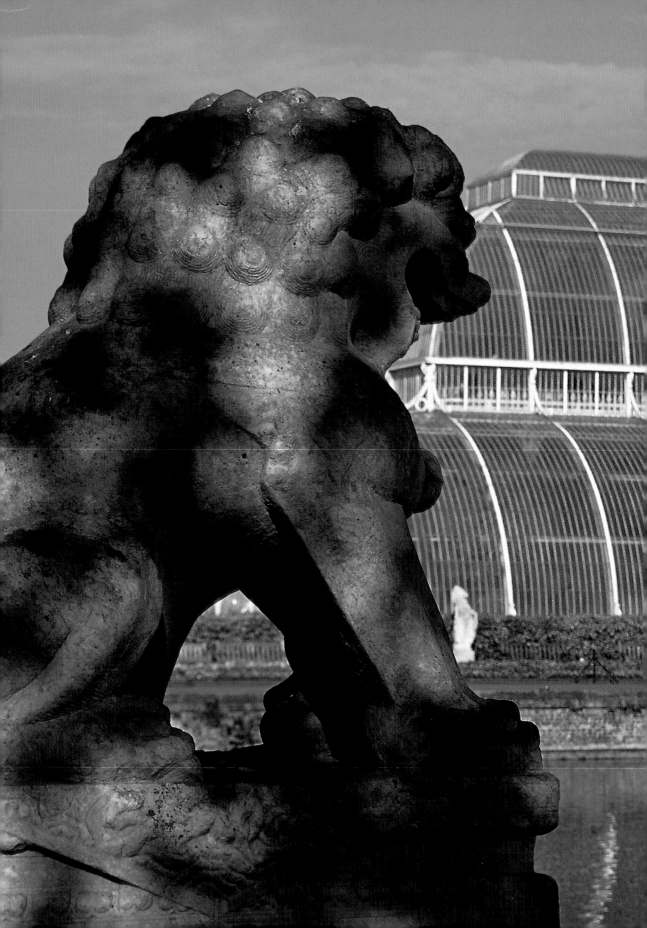

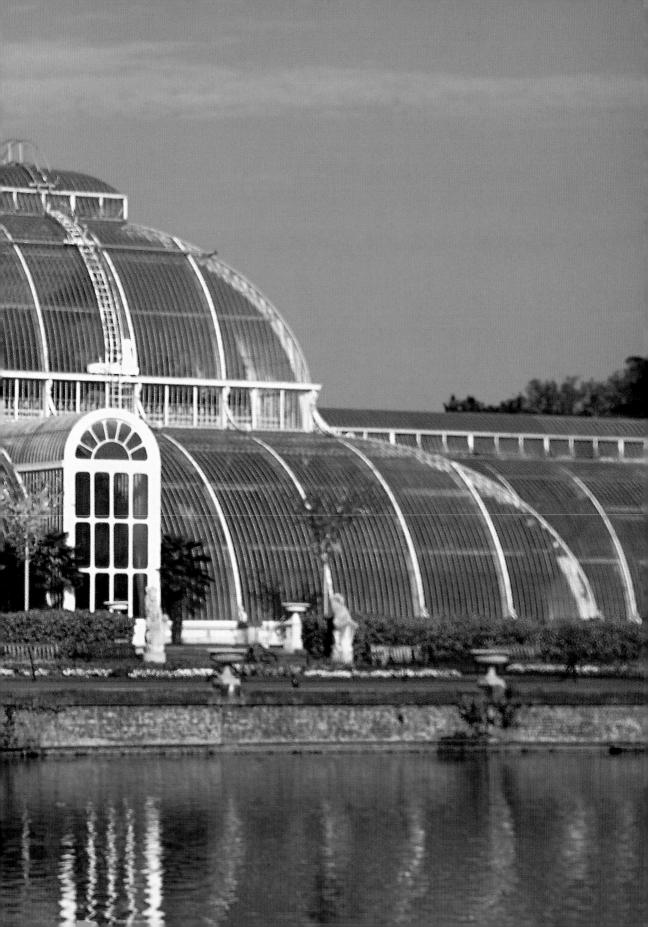

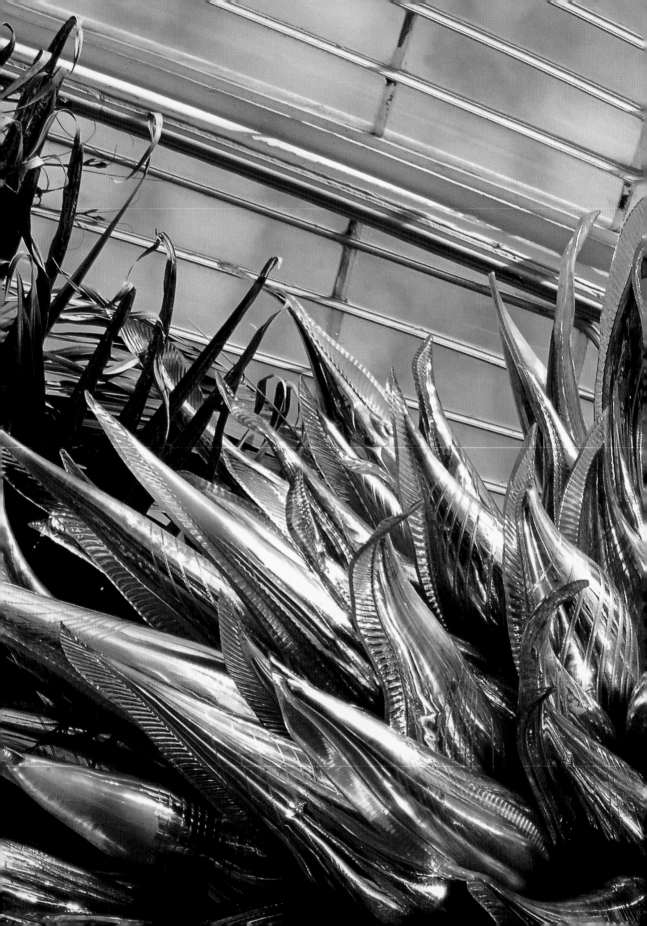

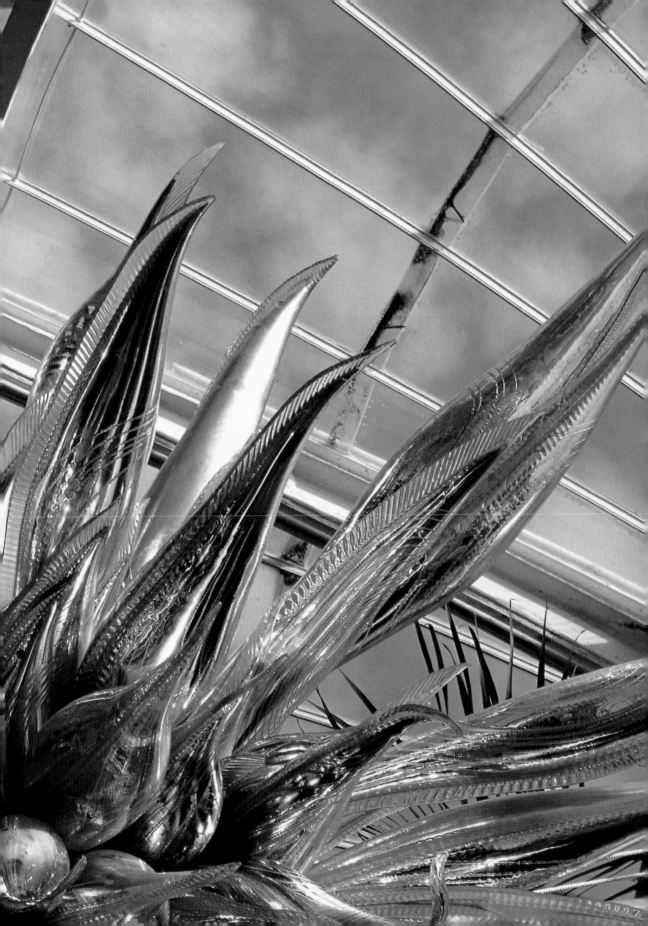

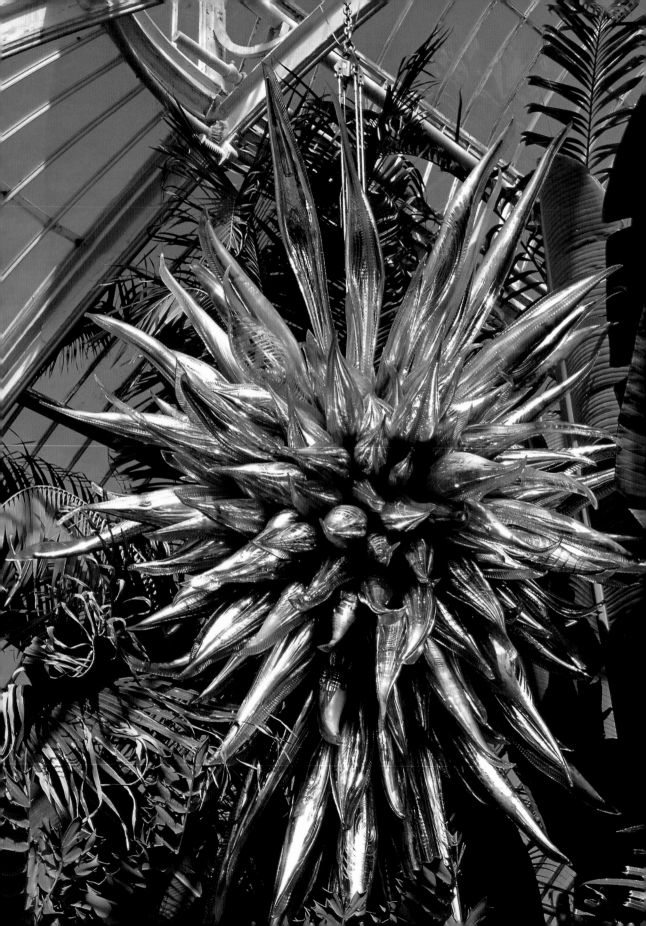

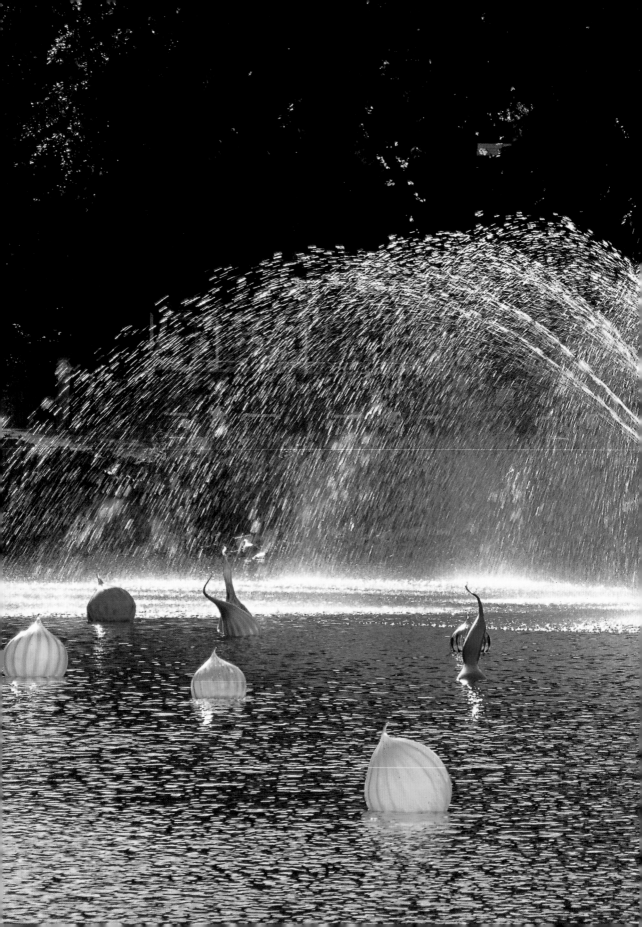

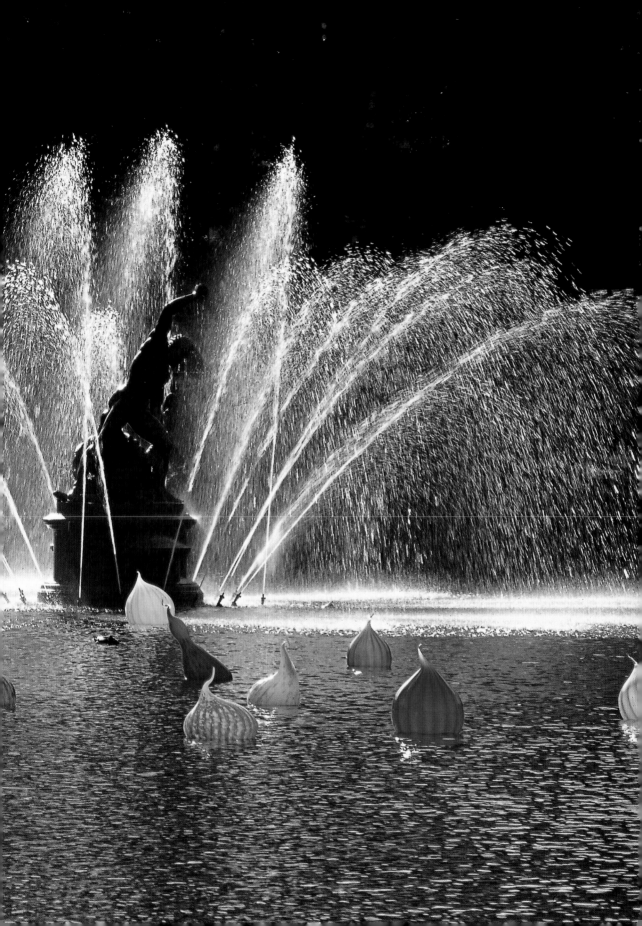

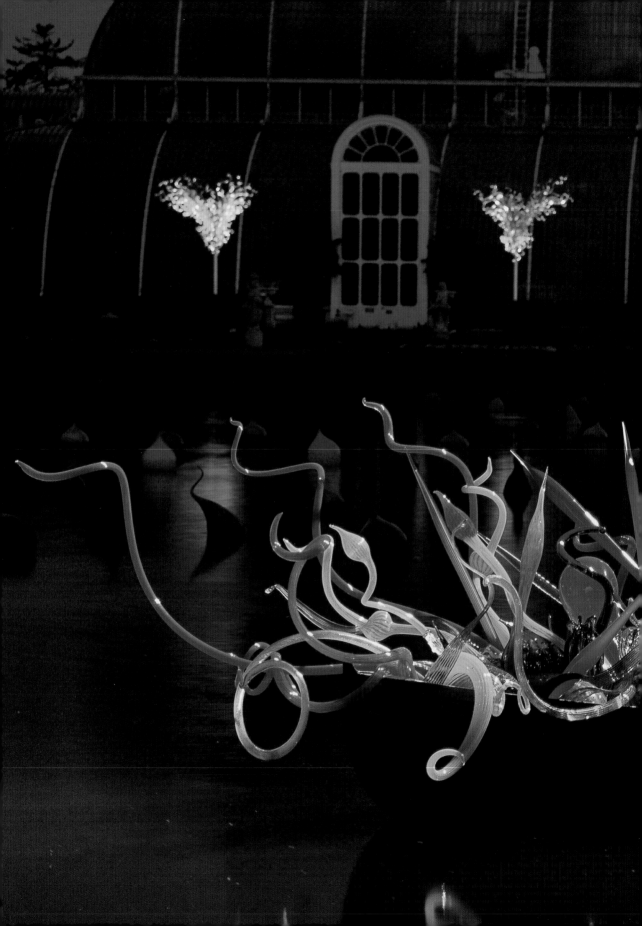

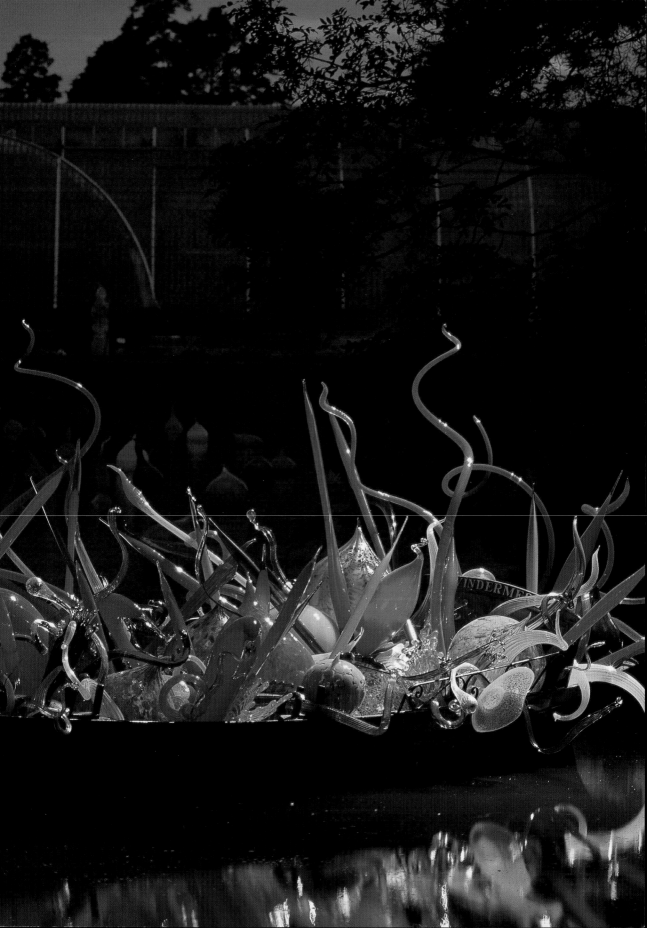

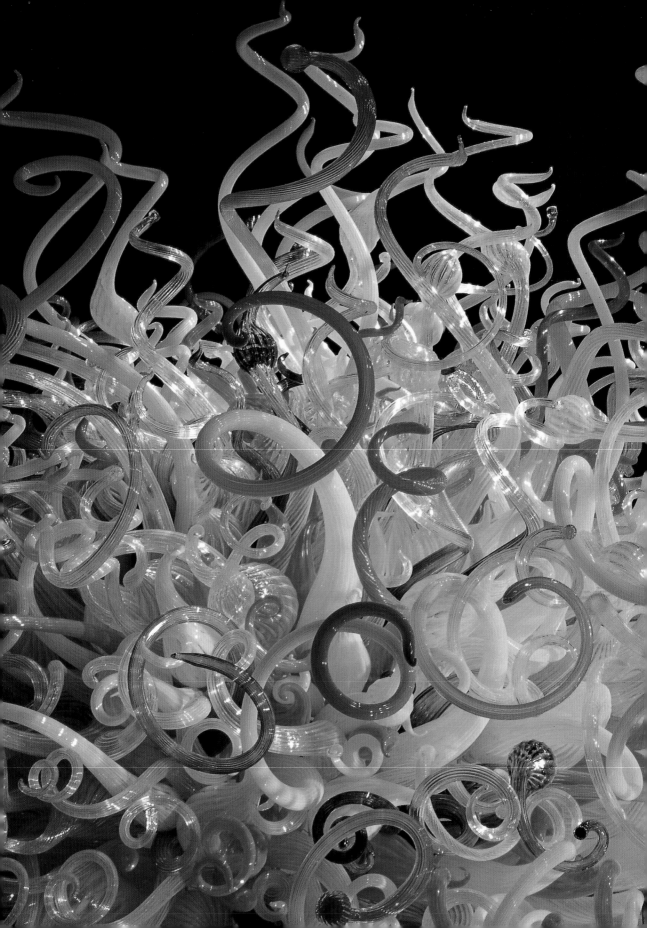

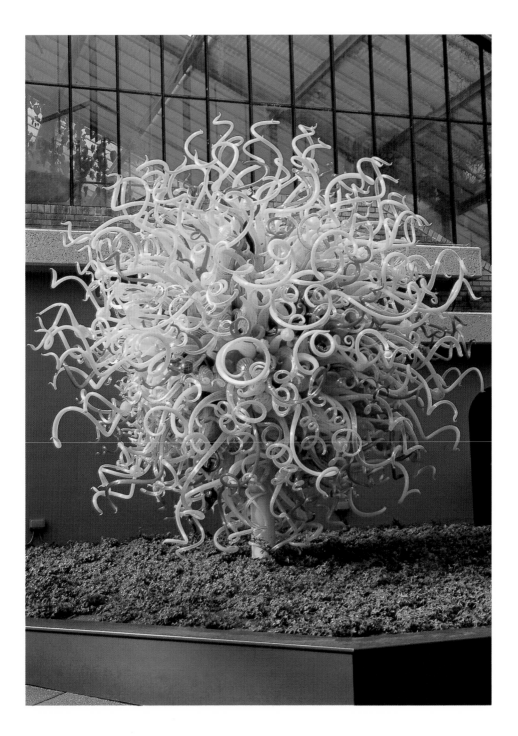

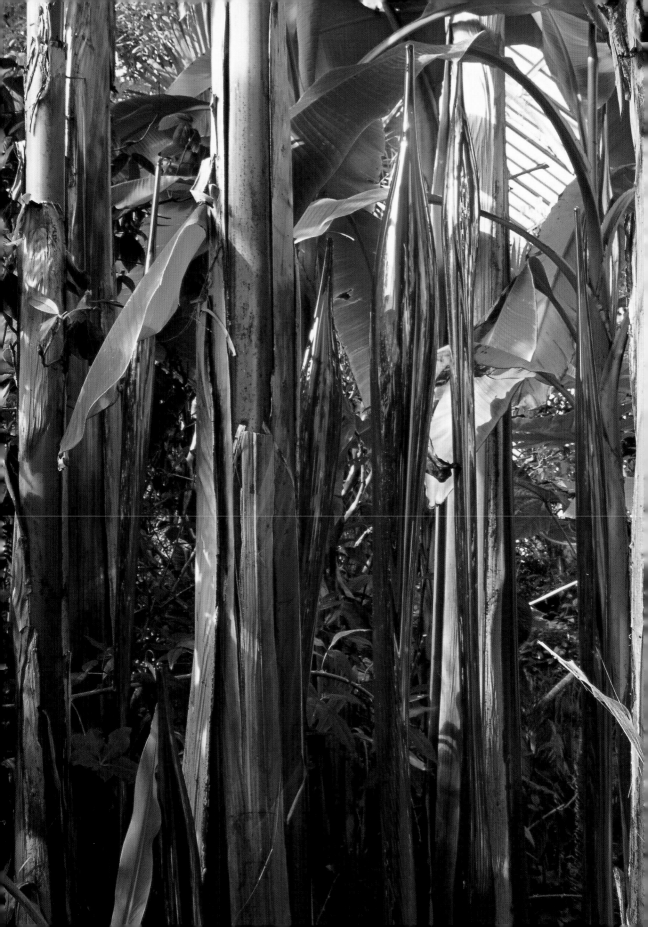

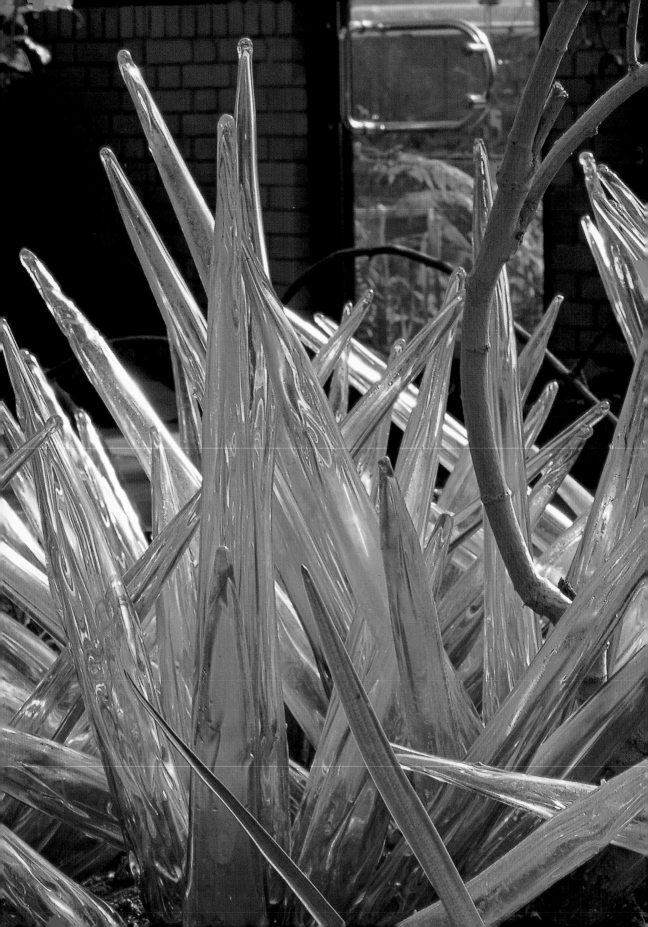

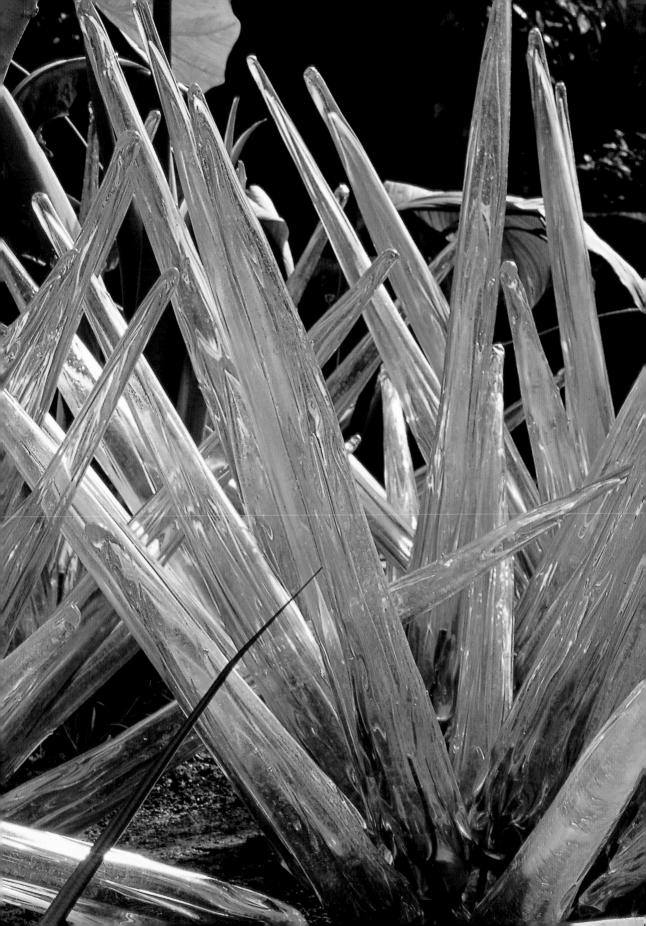

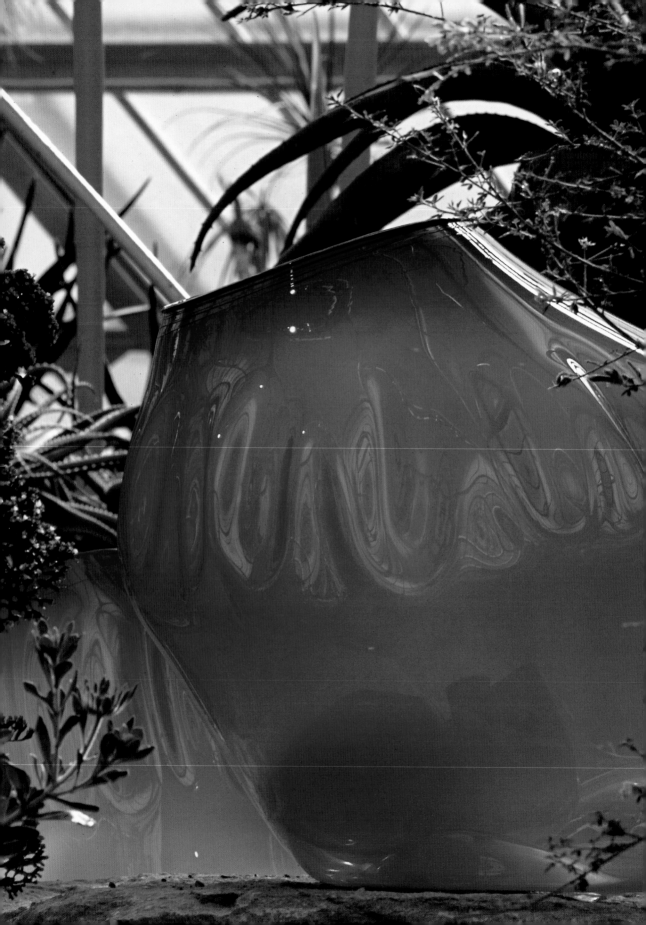

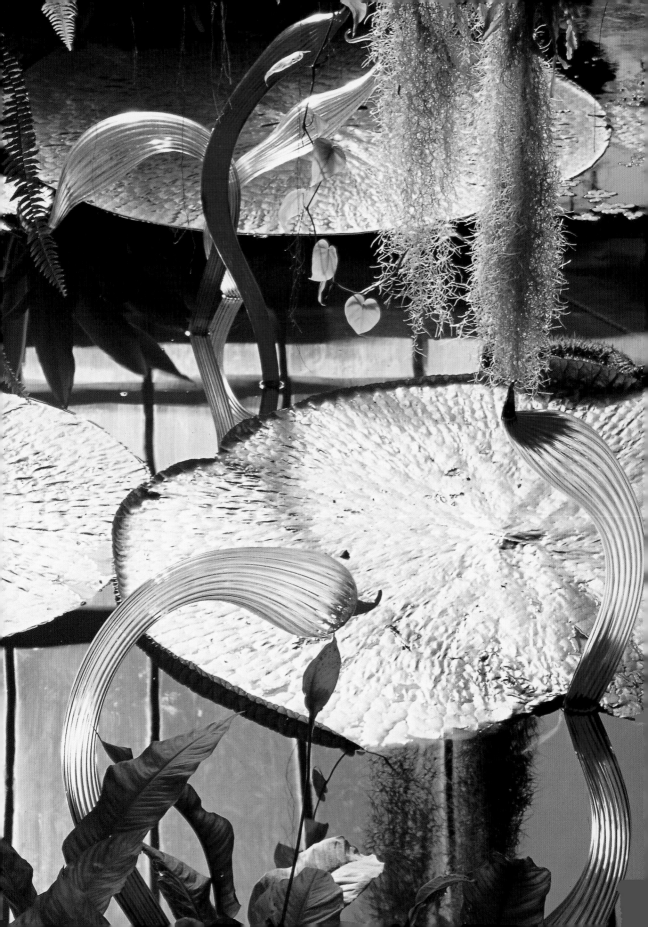

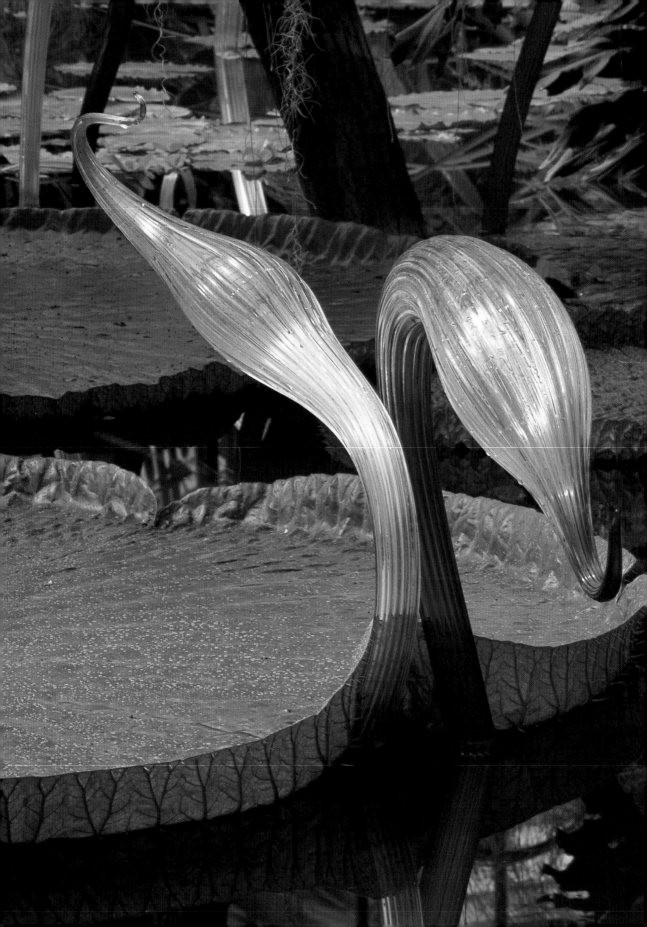

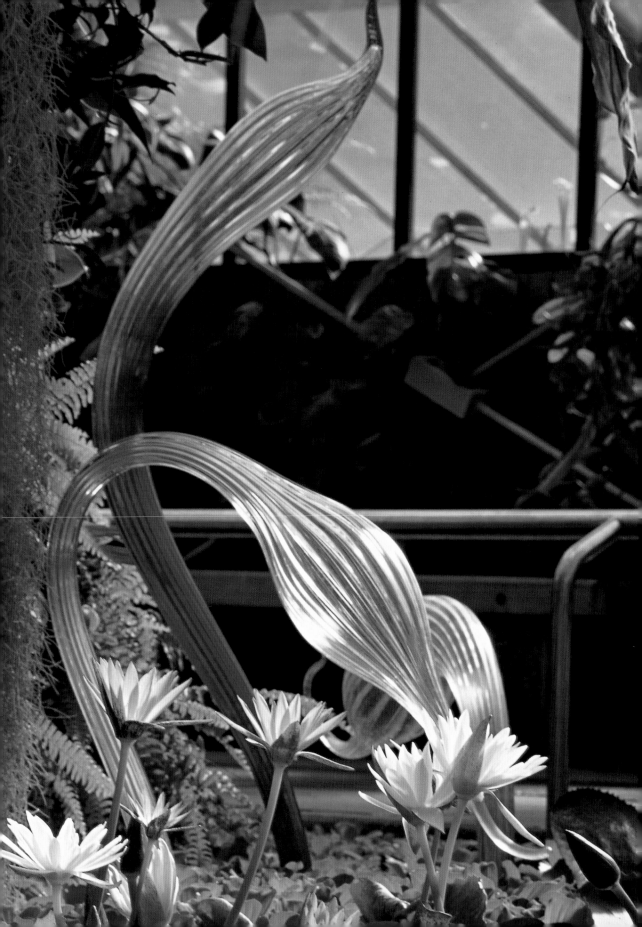

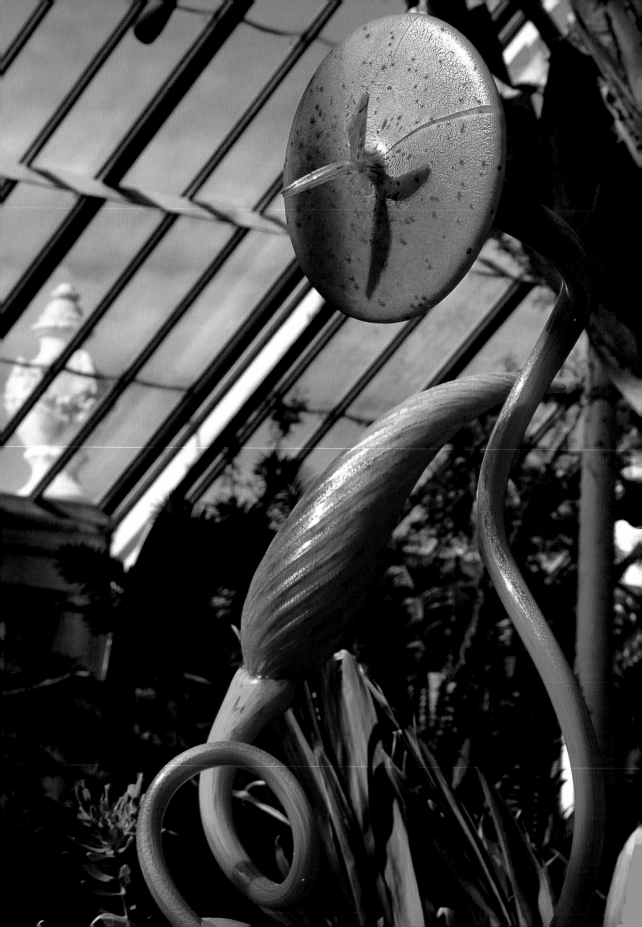

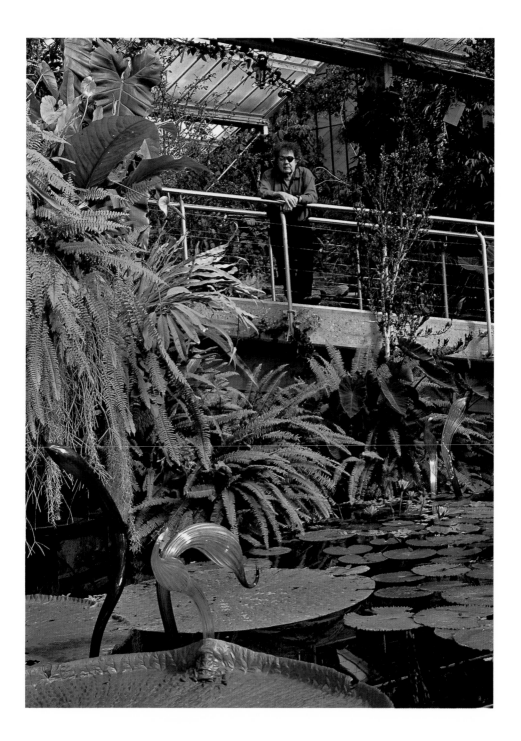

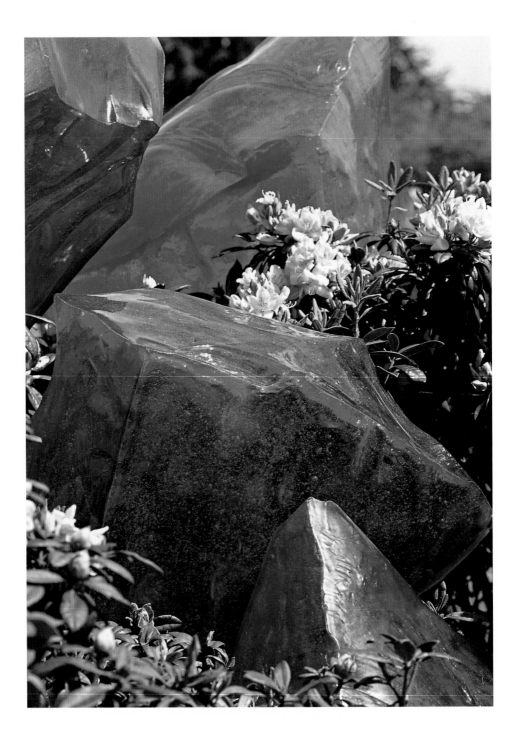

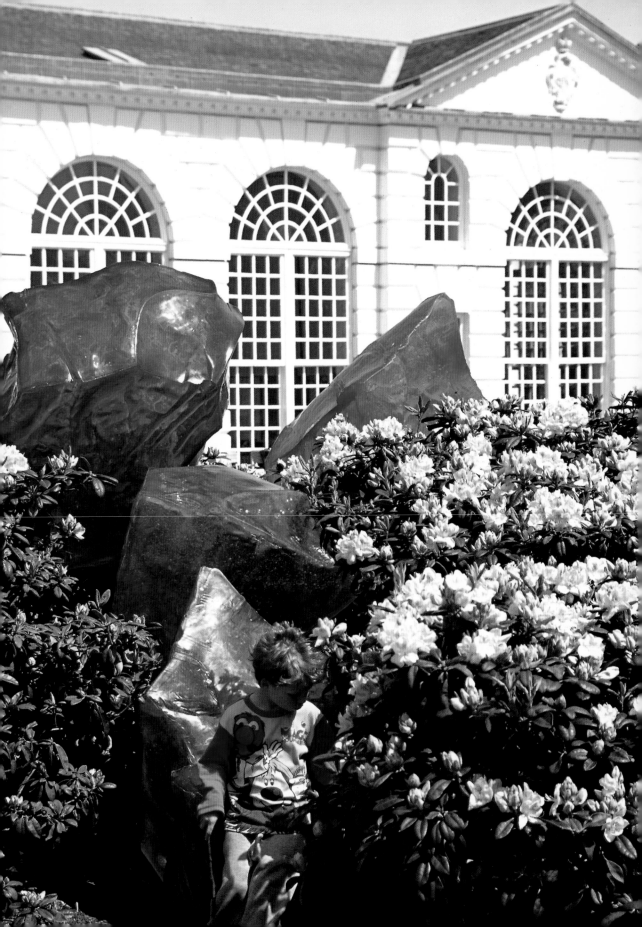

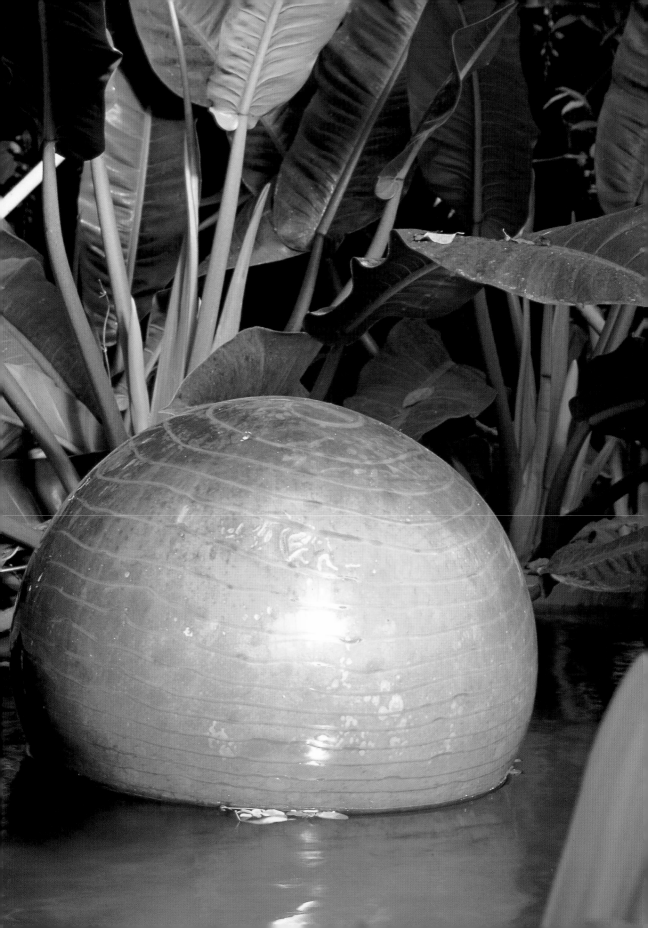

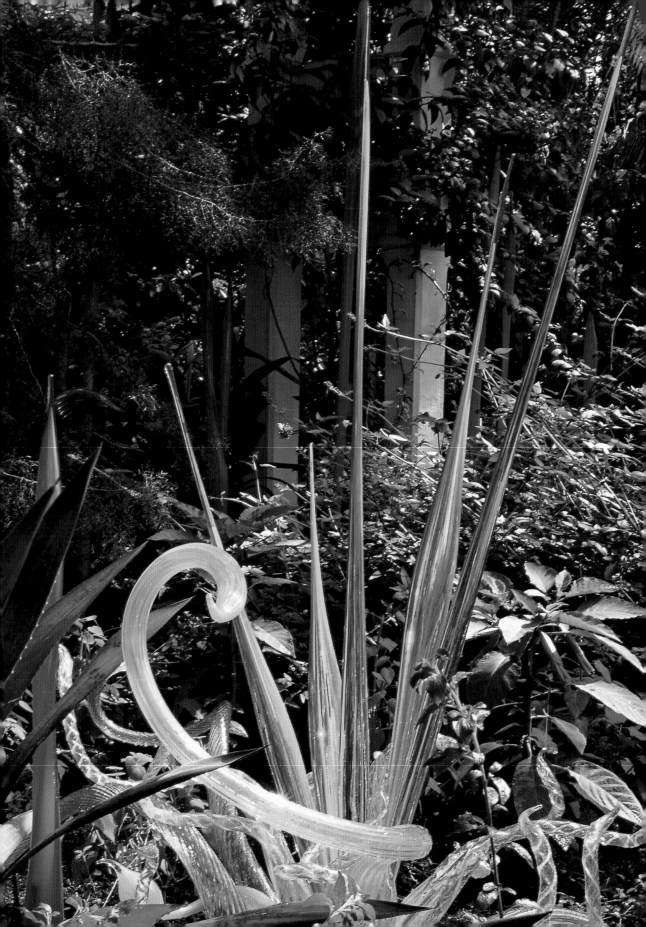

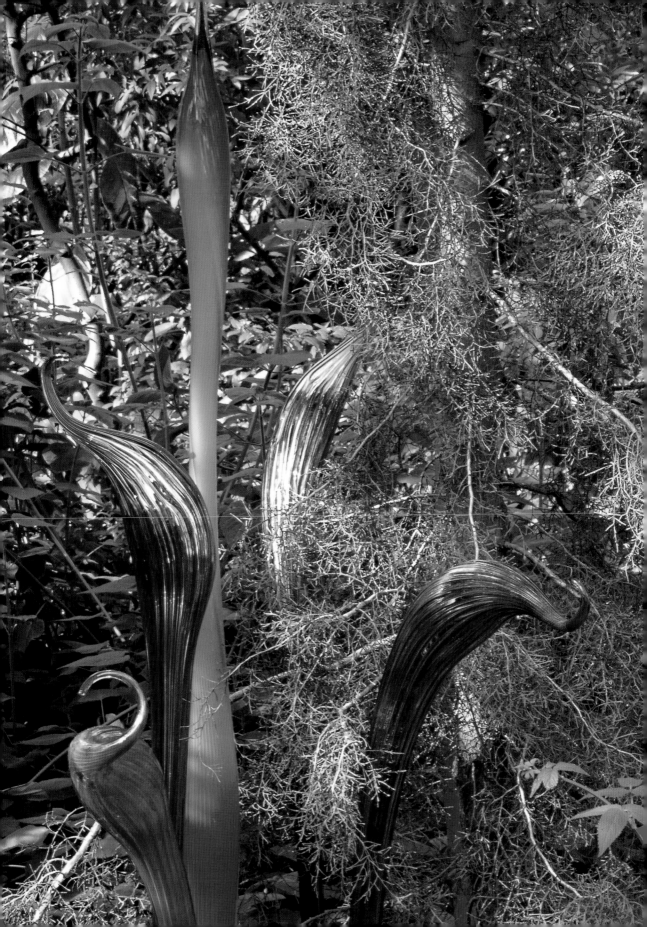

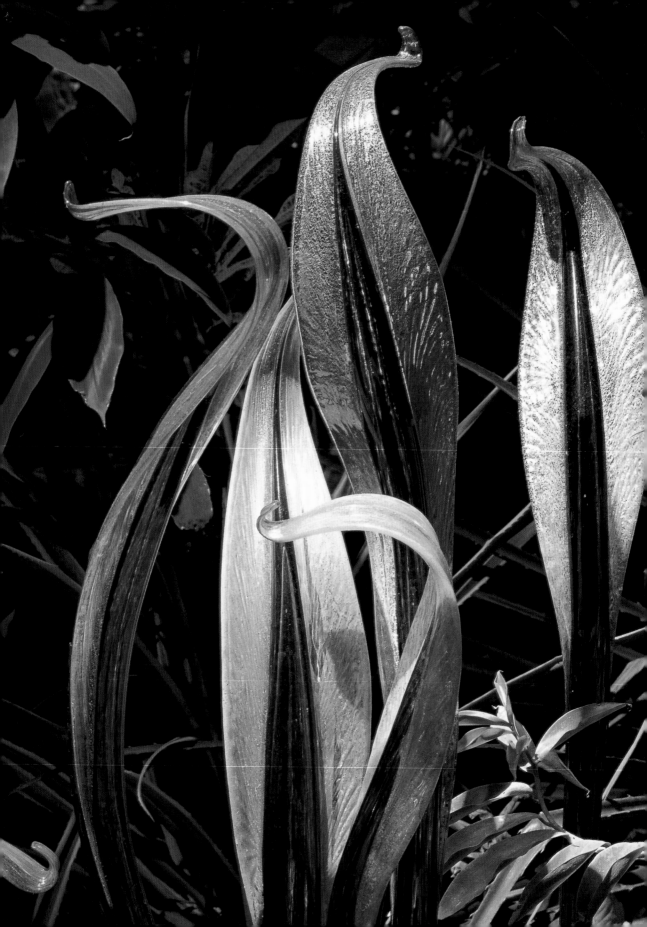

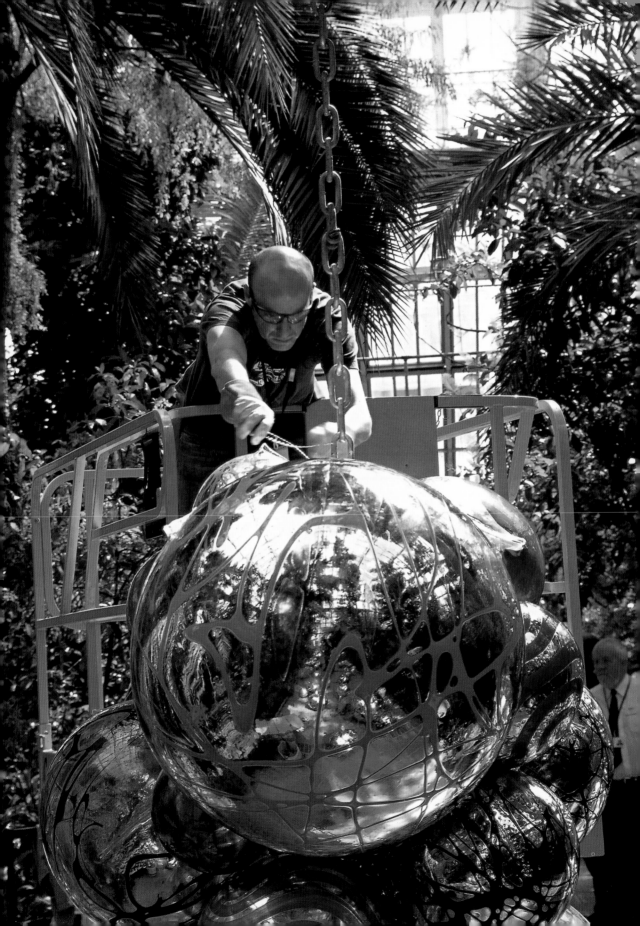

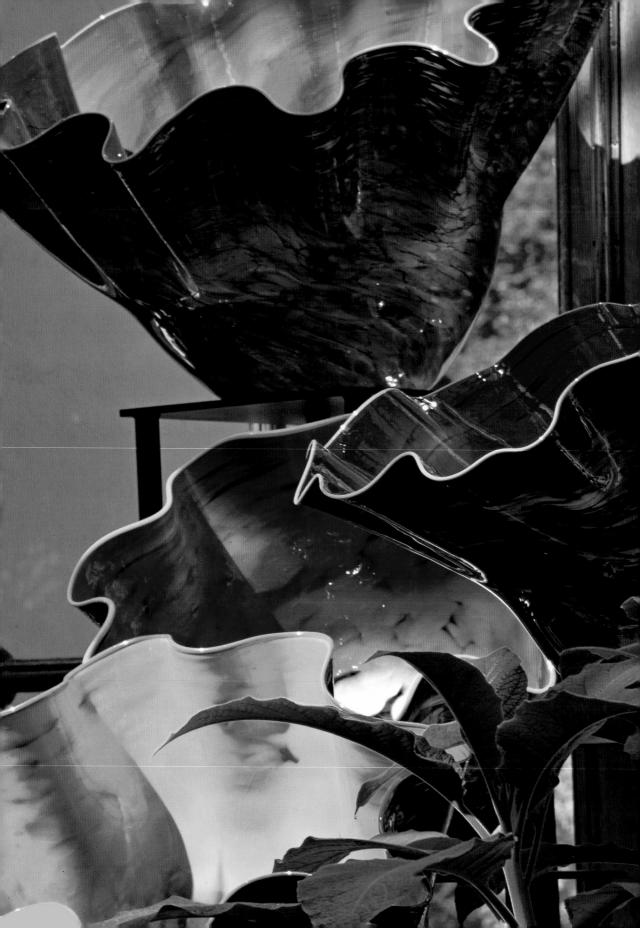

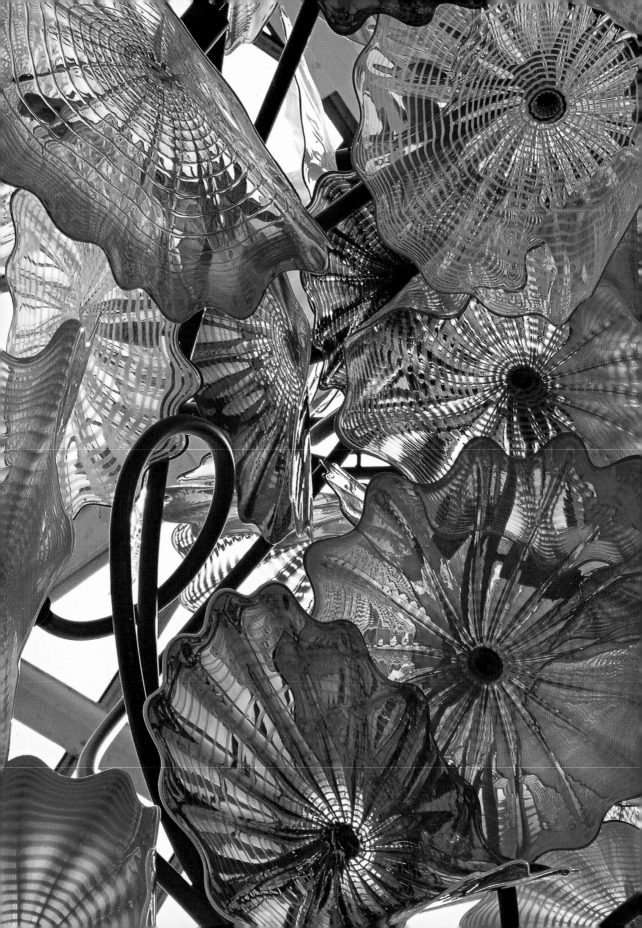

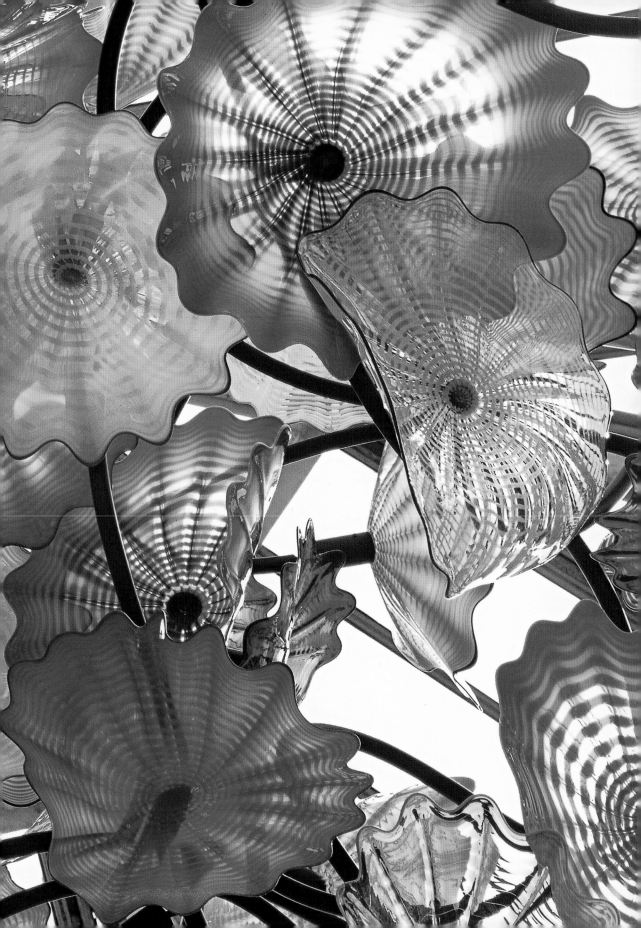

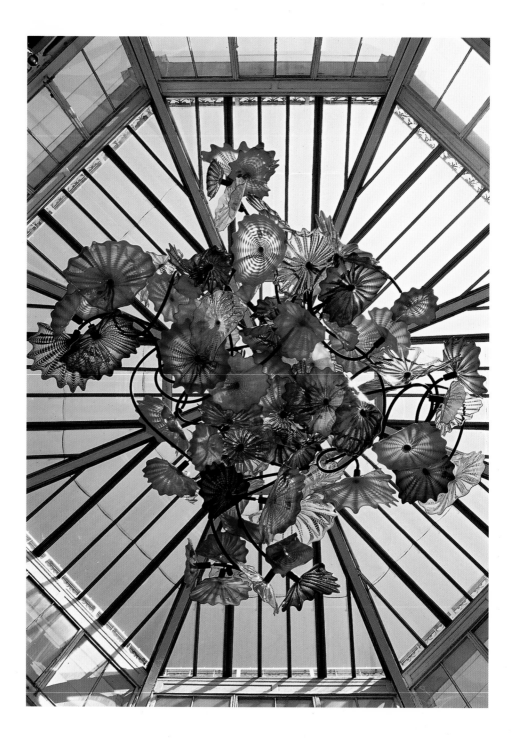

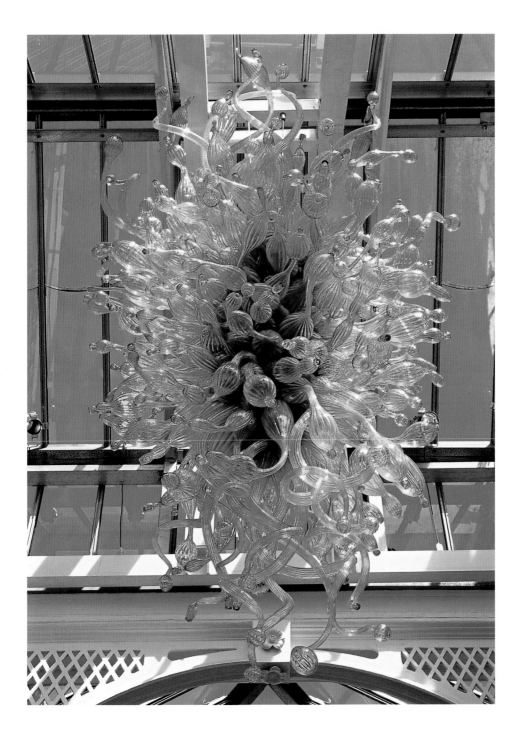

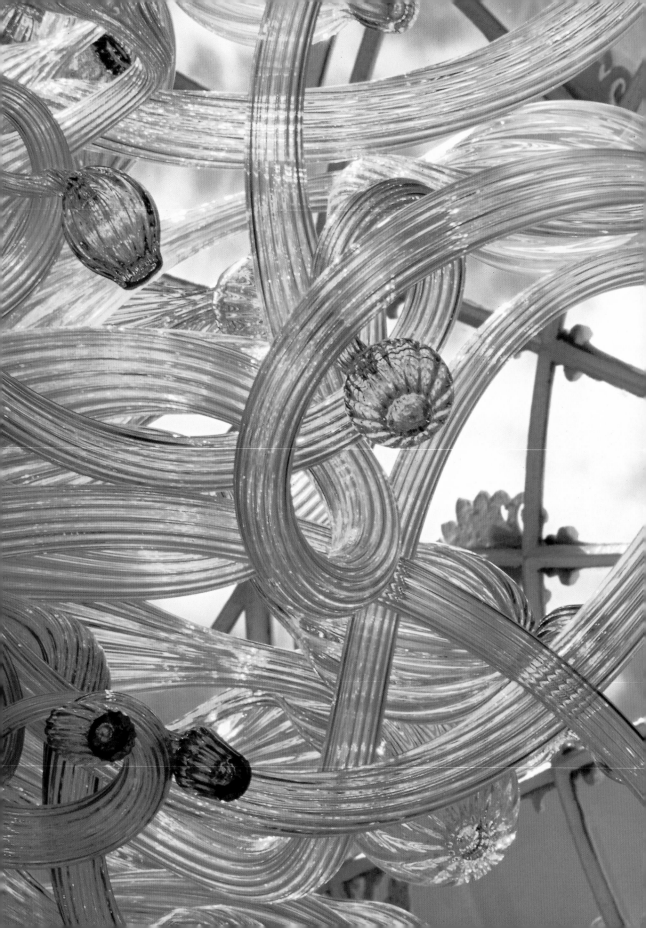

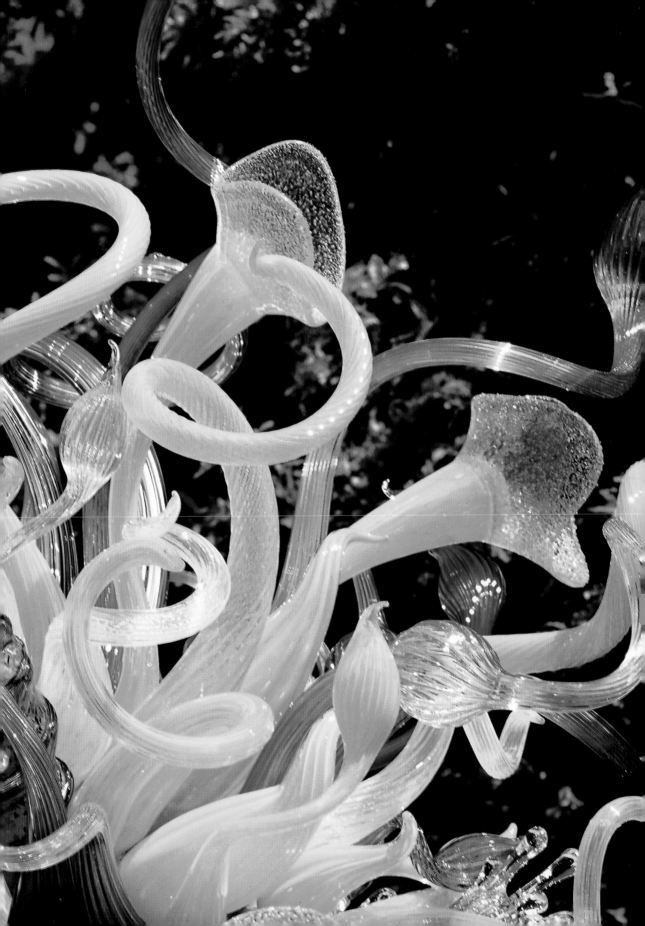

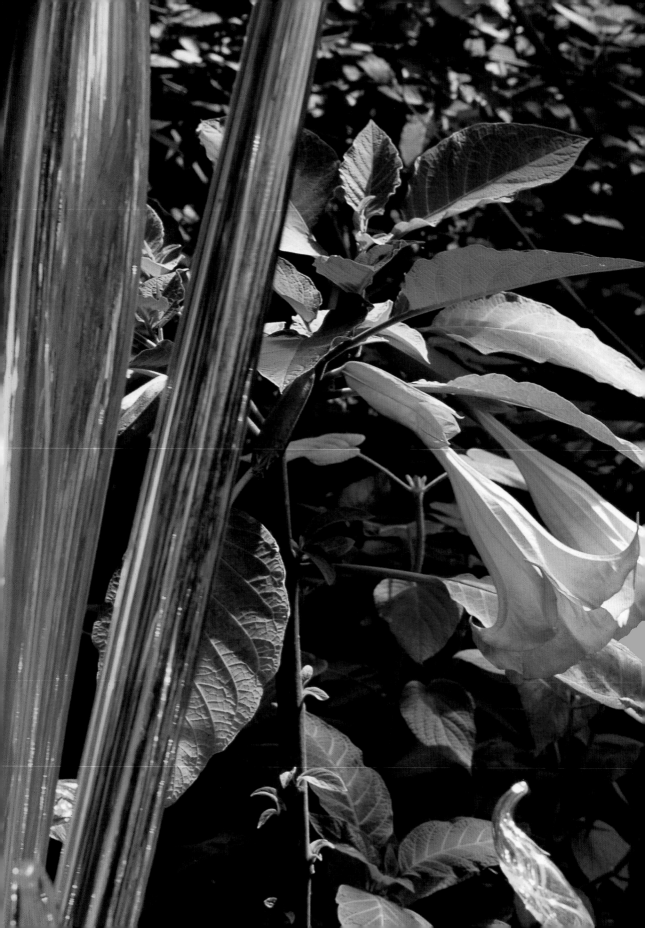

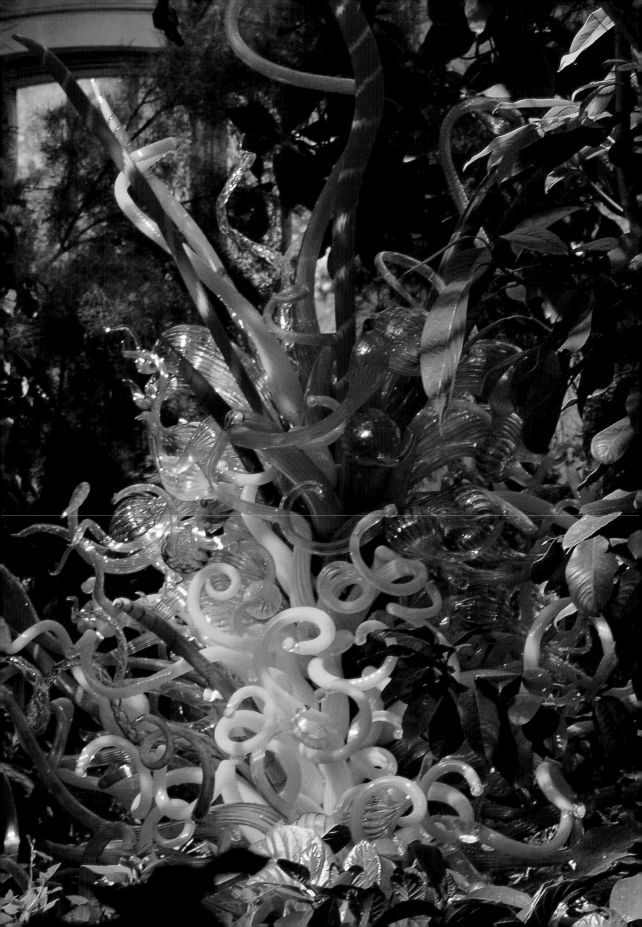

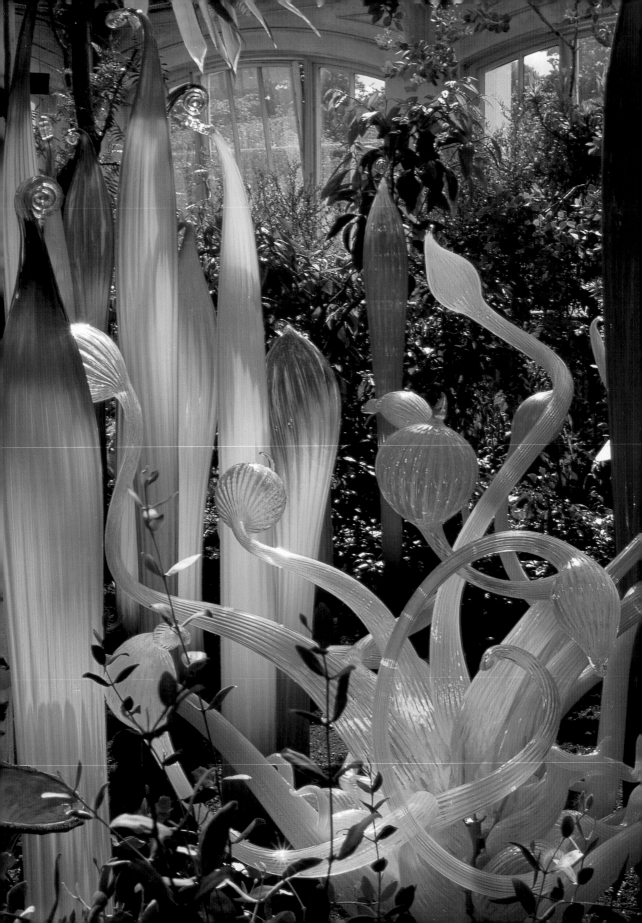

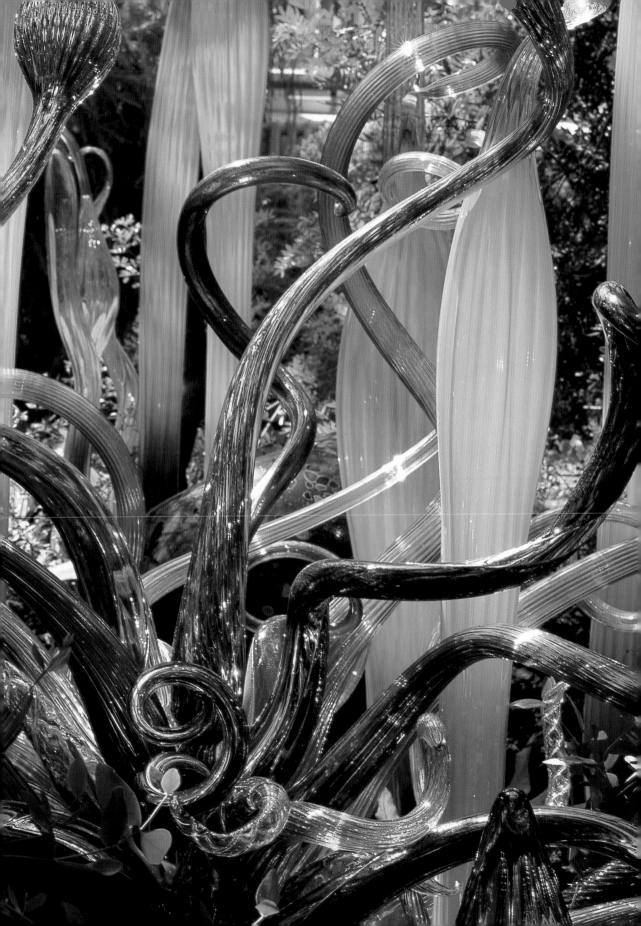

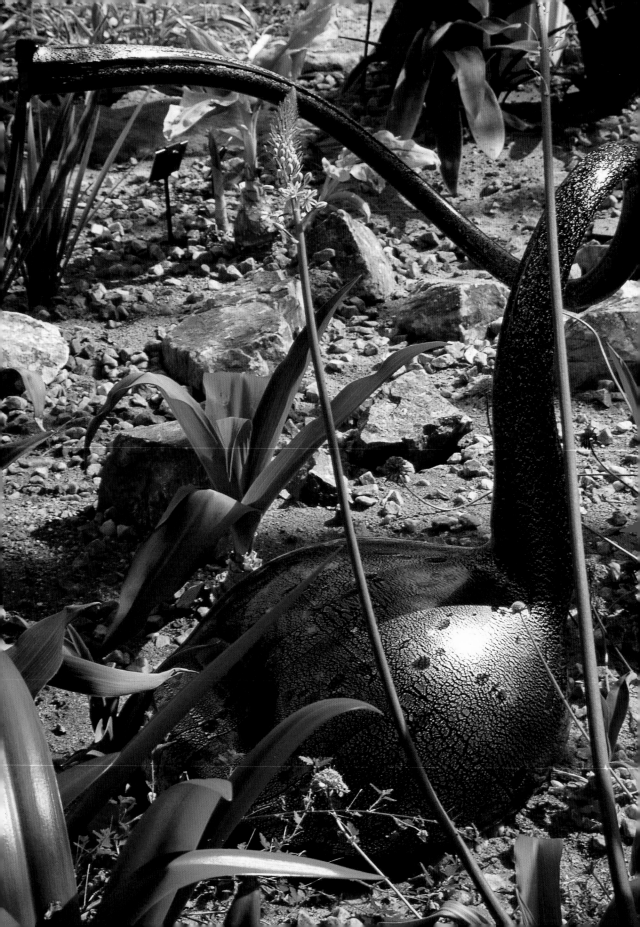

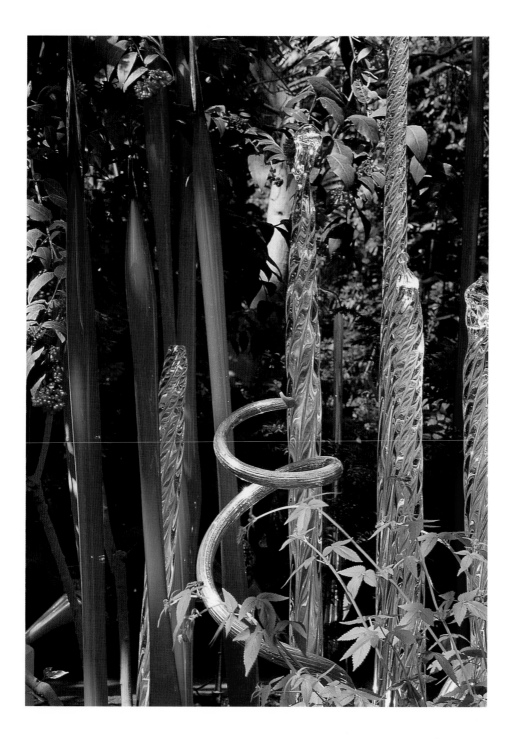

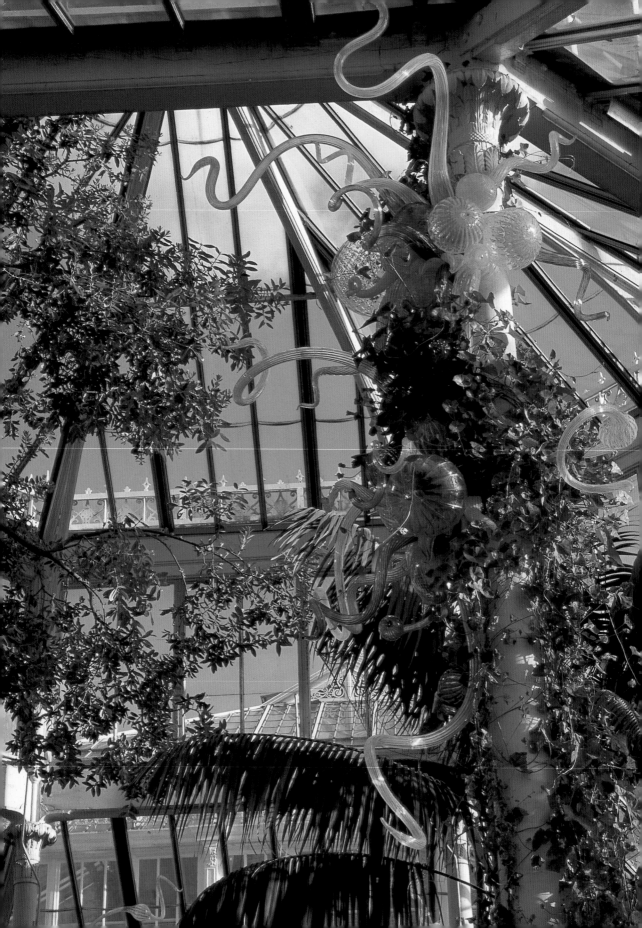

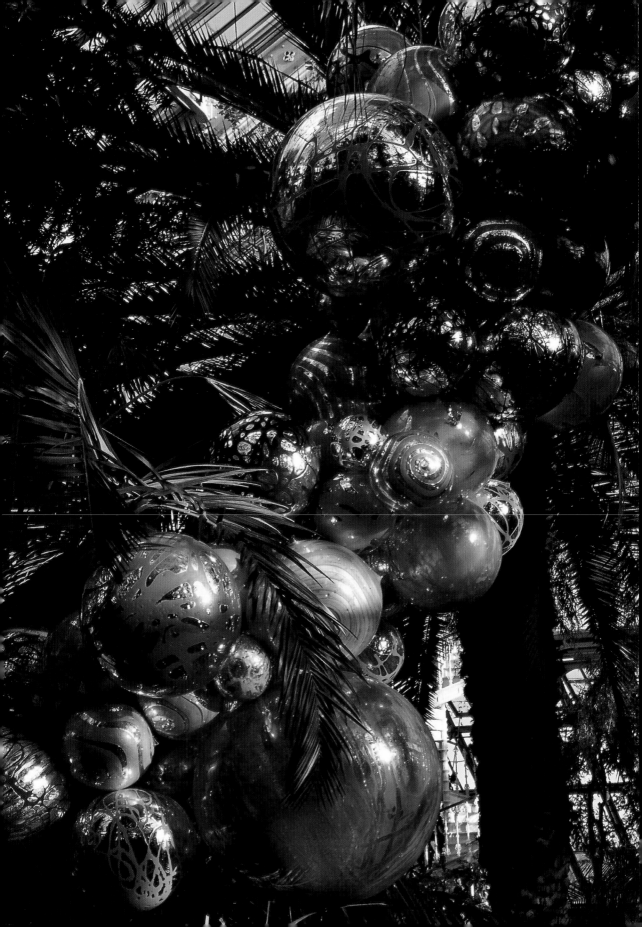

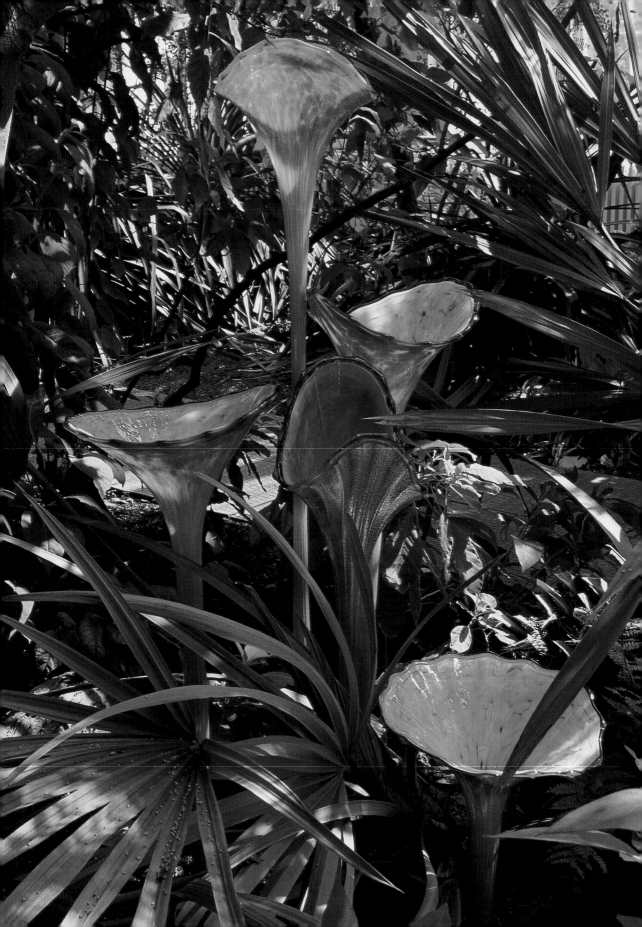

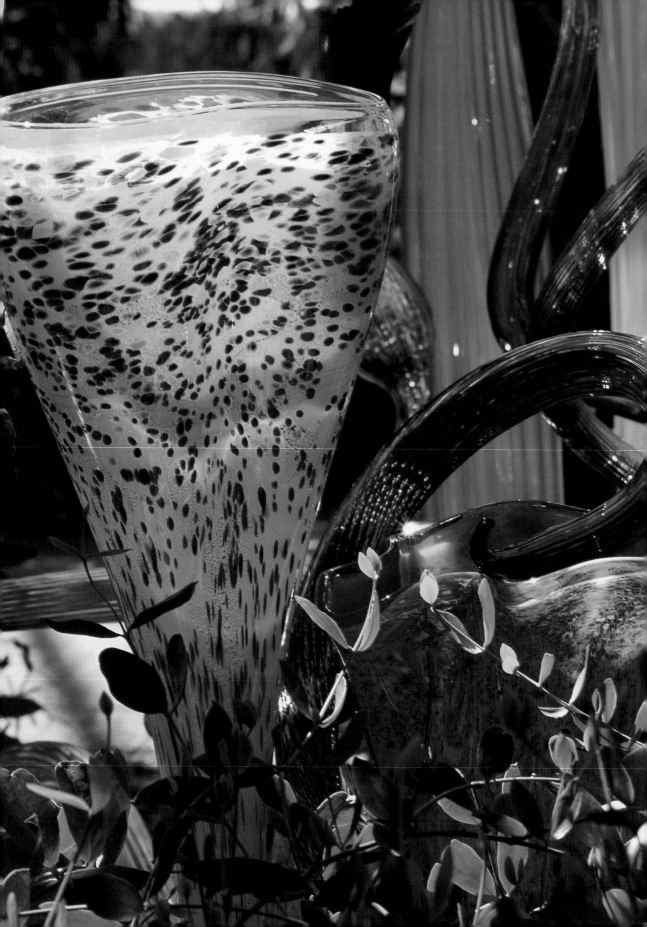

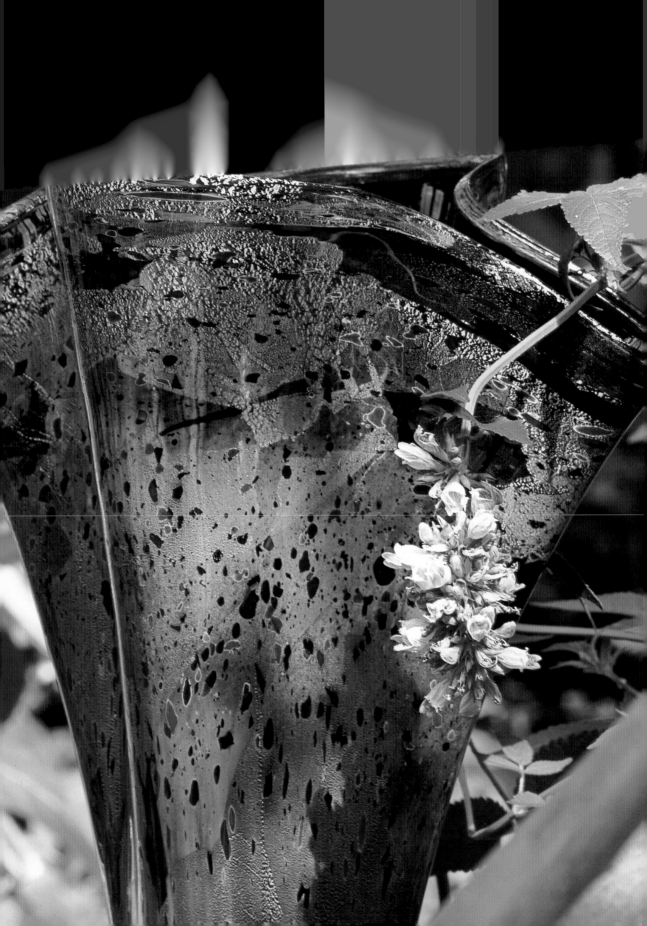

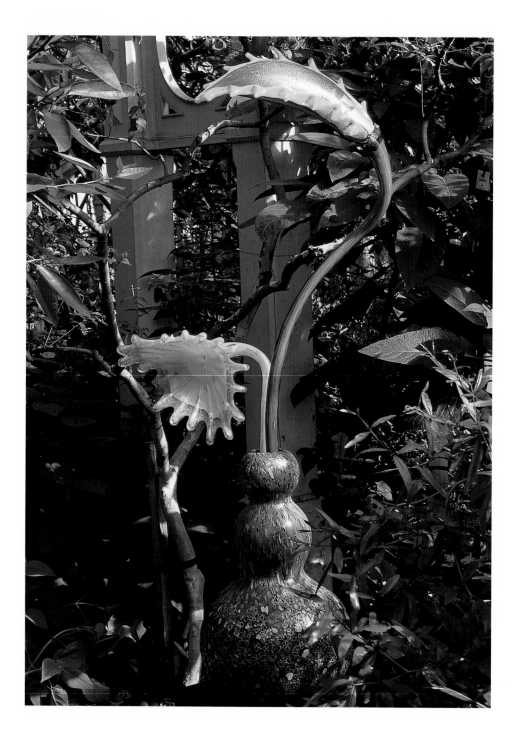

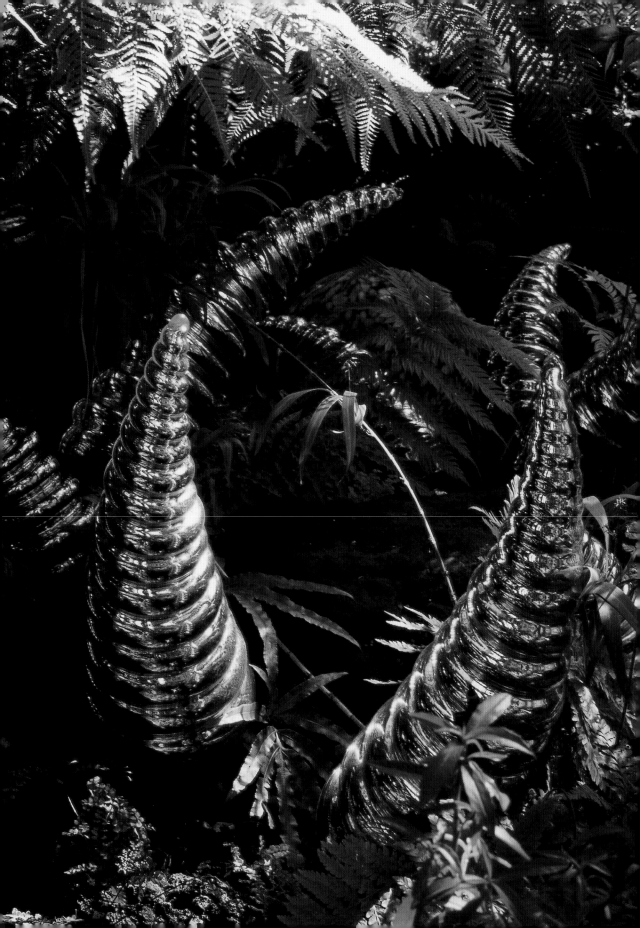

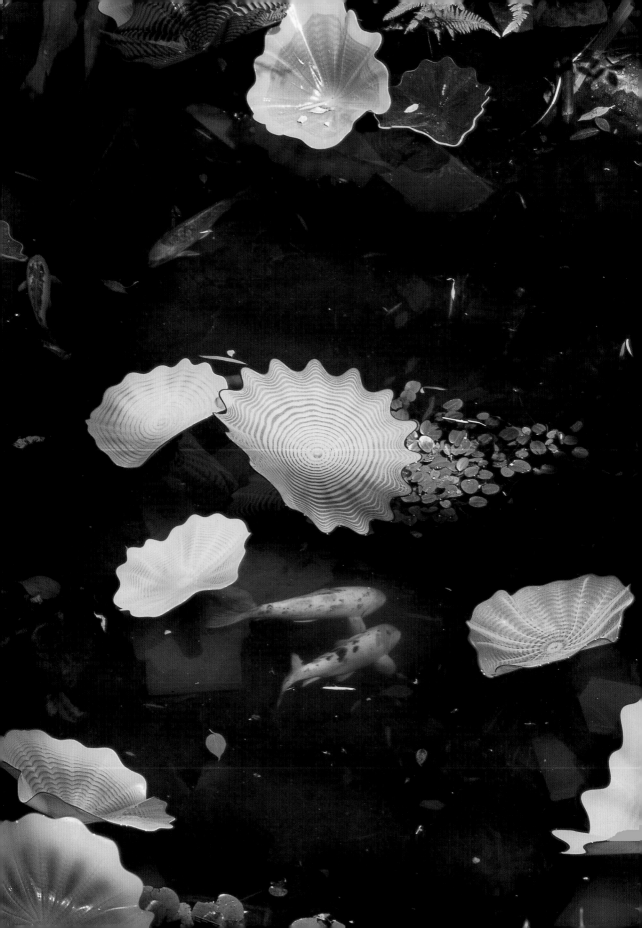

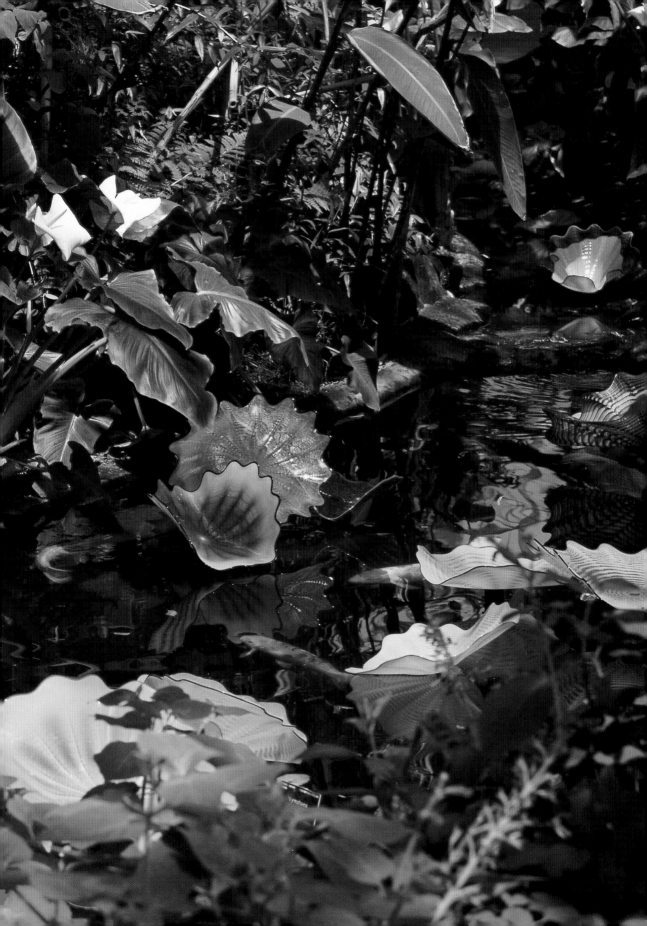

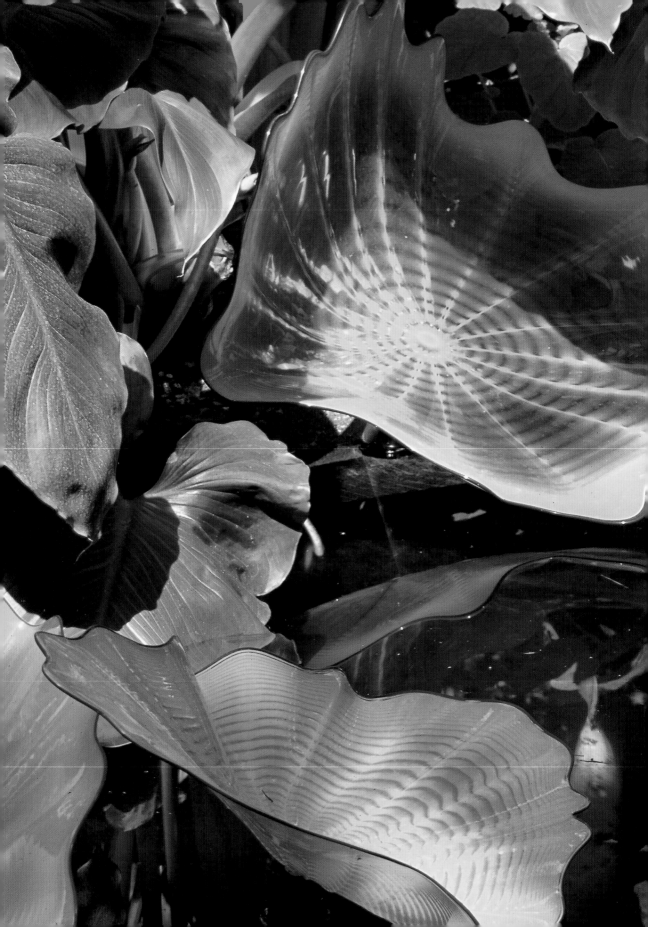

CHRONOLOGY

1941 Born September 20 in Tacoma, Washington, to George Chihuly and Viola Magnuson Chihuly.

1957 Older brother and only sibling, George, is killed in a Naval Air Force training accident in Pensacola, Florida.

1958 His father suffers a fatal heart attack at age 51. His mother goes to work to support herself and Dale.

1959 Graduates from high school in Tacoma. Enrolls in the College of Puget Sound (now the University of Puget Sound) in his hometown. Transfers to the University of Washington in Seattle to study interior design and architecture.

1961 Joins Delta Kappa Epsilon fraternity and becomes rush chairman. Learns to melt and fuse glass.

1962 Disillusioned with his studies, he leaves school and travels to Florence to study art. Discouraged by not being able to speak Italian, he leaves and travels to the Middle East.

1963 Works on a kibbutz in the Negev Desert. Returns to the University of Washington in the College of Arts and Sciences and studies under Hope Foote and Warren Hill. In a weaving class with Doris Brockway, he incorporates glass shards into woven tapestries.

1964 Returns to Europe, visits Leningrad, and makes the first of many trips to Ireland.

1965 Receives B.A. in Interior Design from the University of Washington. Experimenting on his own in his basement studio, Chihuly blows his first glass bubble by melting stained glass and using a metal pipe.

1966 Works as a commercial fisherman in Alaska to earn money for graduate school. Enters the University of Wisconsin at Madison, where he studies glassblowing under Harvey Littleton.

1967 Receives M.S. in Sculpture from the University of Wisconsin. Enrolls at the Rhode Island School of Design (RISD) in Providence, where he begins his exploration of environmental works using neon, argon, and blown glass. Awarded a Louis Comfort Tiffany Foundation Grant for work in glass. Italo Scanga, then on the faculty at Pennsylvania State University's Art Department, lectures at RISD, and the two begin a lifelong friendship.

1968 Receives M.F.A. in Ceramics from RISD. Awarded a Fulbright Fellowship, which enables him to travel and work in Europe. Becomes the first American glassblower to work in the Venini factory on the island of Murano. Returns to the United States and spends four consecutive summers

teaching at Haystack Mountain School of Crafts in Deer Isle, Maine.

1969 Travels again throughout Europe and meets glass masters Erwin Eisch in Germany and Jaroslava Brychtová and Stanislav Libenský in Czechoslovakia. Returning to the United States, Chihuly establishes the glass program at RISD, where he teaches for the next fifteen years.

1970 Meets James Carpenter, a student in the RISD Illustration Department, and they begin a four-year collaboration.

1971 On the site of a tree farm donated by Seattle art patrons Anne Gould Hauberg and John Hauberg, the Pilchuck Glass School is founded. Chihuly's first environmental installation at Pilchuck is created that summer. He resumes teaching at RISD and creates *20,000 Pounds of Ice and Neon*, *Glass Forest #1*, and *Glass Forest #2* with James Carpenter, installations that prefigure later environmental works by Chihuly.

1972 Continues to collaborate with Carpenter on large-scale architectural projects. They create *Rondel Door* and *Cast Glass Door* at Pilchuck. Back in Providence, they create *Dry Ice, Bent Glass and Neon*, a conceptual breakthrough.

1974 Supported by a National Endowment for the Arts grant at Pilchuck, James Carpenter, a group of students, and he develop a technique for picking up glass thread drawings. In December at RISD, he completes his last collaborative project with Carpenter, *Corning Wall*.

1975 At RISD, begins series of *Navajo Blanket Cylinders*. Kate Elliott and, later, Flora Mace fabricate the complex thread drawings. He receives the first of two National Endowment for the Arts Individual Artist grants. Artist-in-residence with Seaver Leslie at Artpark, on the Niagara Gorge, in New York State. Begins *Irish Cylinders* and *Ulysses Cylinders* with Leslie and Mace.

1976 An automobile accident in England leaves him, after weeks in the hospital and 256 stitches in his face, without sight in his left eye and with permanent damage to his right ankle and foot. After recuperating he returns to Providence to serve as head of the Department of Sculpture and the Program in Glass at RISD. Henry Geldzahler, curator of contemporary art at the Metropolitan Museum of Art in New York, acquires three *Navajo Blanket Cylinders* for the museum's collection. This is a turning point in Chihuly's career, and a friendship between artist and curator commences.

1977 Inspired by Northwest Coast Indian baskets he sees at the

147

Washington Historical Society in Tacoma, begins the *Basket* series at Pilchuck over the summer, with Benjamin Moore as his assistant gaffer. Continues his bicoastal teaching assignments, dividing his time between Rhode Island and the Pacific Northwest.

1978 Meets William Morris, a student at Pilchuck Glass School, and the two begin a close, eight-year working relationship. A solo show, *Baskets and Cylinders* curated by Michael W. Monroe at the Renwick Gallery, Smithsonian Institution, in Washington, D.C., is another career milestone.

1979 Dislocates his shoulder in a bodysurfing accident and relinquishes the gaffer position for good. William Morris becomes his chief gaffer for the next several years. Chihuly begins to make drawings as a way to communicate his designs.

1980 Resigns his teaching position at RISD. He returns there periodically during the 1980s as artist-in-residence. Begins *Seaform* series at Pilchuck in the summer and later, back in Providence, returns to architectural installations with the creation of windows for the Shaare Emeth Synagogue in St. Louis, Missouri.

1981 Begins *Macchia* series.

1982 First major catalog is published: *Chihuly Glass*, designed by RISD colleague and friend Malcolm Grear.

1983 Returns to the Pacific Northwest after sixteen years on the East Coast. Works at Pilchuck in the fall and winter, further developing the *Macchia* series with William Morris as chief gaffer.

1984 Begins work on the *Soft Cylinder* series, with Flora Mace and Joey Kirkpatrick executing the glass drawings.

1985 Begins working hot glass on a larger scale and creates several site-specific installations.

1986 Begins *Persian* series with Martin Blank, a former RISD student and assistant, as gaffer. With the opening of *Objets de Verre* at the Musée des Arts Décoratifs, Palais du Louvre, in Paris, he becomes one of only four American artists to have had a one-person exhibition at the Louvre.

1987 Establishes his first hotshop in the Van de Kamp building near Lake Union. Begins association with artist Parks Anderson. Marries playwright Sylvia Peto.

1988 Inspired by a private collection of Italian Art Deco glass, Chihuly begins *Venetian* series. Working from Chihuly's drawings, Lino Tagliapietra serves as gaffer.

1989 With Italian glass masters Lino Tagliapietra, Pino Signoretto, and a team of glassblowers at Pilchuck Glass School, begins *Putti Venetian* series.

Working with Tagliapietra, Chihuly creates *Ikebana* series, inspired by his travels to Japan and exposure to ikebana masters.

1990 Purchases the historic Pocock Building located on Lake Union, realizing his dream of being on the water in Seattle. Renovates the building and names it The Boathouse, for use as a studio, hotshop, and archives. Travels to Japan.

1991 Begins *Niijima Float* series with Rich Royal as gaffer, creating some of the largest pieces of glass ever blown by hand. Completes a number of architectural installations. He and Sylvia Peto divorce.

1992 Begins *Chandelier* series with a hanging sculpture at the Seattle Art Museum. Designs sets for Seattle Opera production of Debussy's *Pelléas et Mélisande*.

1993 Begins *Piccolo Venetian* series with Lino Tagliapietra. Creates *100,000 Pounds of Ice and Neon*, a temporary installation in the Tacoma Dome, Tacoma, Washington.

1994 Creates five installations for Tacoma's Union Station Federal Courthouse. Hilltop Artists in Residence, a glassblowing program for at-risk youths in Tacoma, Washington, is created by friend Kathy Kaperick. Within two years the program partners with Tacoma Public Schools, and

Chihuly remains a strong role model and advisor.

1995 *Chihuly Over Venice* begins with a glassblowing session in Nuutajärvi, Finland, and a subsequent blow at the Waterford Crystal factory, Ireland.

1996 *Chihuly Over Venice* continues with a blow in Monterrey, Mexico, and culminates with the installation of fourteen *Chandeliers* at various sites in Venice. Creates his first permanent outdoor installation, *Icicle Creek Chandelier*.

1997 Continues and expands series of experimental plastics he calls Polyvitro. *Chihuly* is designed by Massimo Vignelli and copublished by Harry N. Abrams, Inc., New York, and Portland Press, Seattle. A permanent installation of Chihuly's work opens at the Hakone Glass Forest, Ukai Museum, in Hakone, Japan.

1998 Chihuly is invited to Sydney, Australia, with his team to participate in the Sydney Arts Festival. A son, Jackson Viola Chihuly, is born February 12 to Dale Chihuly and Leslie Jackson. Creates architectural installations for Benaroya Hall, Seattle; Bellagio, Las Vegas; and Atlantis, the Bahamas.

1999 Begins *Jerusalem Cylinder* series with gaffer James Mongrain, in concert with Flora Mace and Joey Kirkpatrick. Mounts his most

ambitious exhibition to date: *Chihuly in the Light of Jerusalem 2000*, at the Tower of David Museum of the History of Jerusalem. Outside the Museum he creates a sixty-foot wall from twenty-four massive blocks of ice shipped from Alaska.

2000 Creates *La Tour de Lumière* sculpture as part of the exhibition *Contemporary American Sculpture in Monte Carlo*. Marlborough Gallery represents Chihuly. More than a million visitors enter the Tower of David Museum to see *Chihuly in the Light of Jerusalem 2000*, breaking the world attendance record for a temporary exhibition during 1999–2000.

2001 The Victoria and Albert Museum, in London, curates the exhibition *Chihuly at the V&A*. Exhibits at Marlborough Gallery, New York and London. Groups a series of *Chandeliers* for the first time to create an installation for the Mayo Clinic in Rochester, Minnesota. Artist Italo Scanga dies, friend and mentor for over three decades. Presents his first major glasshouse exhibition, *Chihuly in the Park: A Garden of Glass*, at the Garfield Park Conservatory, Chicago.

2002 Creates installations for the Salt Lake 2002 Olympic Winter Games. The Chihuly Bridge of Glass, conceived by Chihuly and designed in collaboration with Arthur Andersson of Andersson·Wise Architects, is dedicated in Tacoma, Washington.

2003 Begins the *Fiori* series for the opening exhibition at the Tacoma Art Museum's new building. TAM designs a permanent installation for its collection of his works. *Chihuly at the Conservatory* opens at the Franklin Park Conservatory, Columbus, Ohio.

2004 Creates new forms in his *Fiori* series for an exhibition at Marlborough Gallery, New York. The Orlando Museum of Art and the Museum of Fine Arts, St. Petersburg, Florida, become the first museums to collaborate and present simultaneous major exhibitions of his work. Presents a glasshouse exhibition at Atlanta Botanical Garden. Another collaborative exhibition opens in Los Angeles at the Frederick R. Weisman Museum of Art, L.A. Louver gallery, and Frank Lloyd Gallery.

2005 Mounts *Gardens of Glass: Chihuly at Kew*, a major garden exhibition, the first in Great Britain. Exhibits at Marlborough Monaco and Marlborough London. Marries Leslie Jackson.

MUSEUM COLLECTIONS

Akita Senshu Museum of Art, Akita, Japan
Akron Art Museum, Akron, Ohio
Albany Museum of Art, Albany, Georgia
Albright-Knox Art Gallery, Buffalo, New York
Allied Arts Association, Richland, Washington
Arizona State University Art Museum, Tempe, Arizona
Arkansas Arts Center, Little Rock, Arkansas
Art Gallery of Greater Victoria, Victoria, British Columbia, Canada
Art Gallery of Western Australia, Perth, Australia
Art Museum of Missoula, Missoula, Montana
Art Museum of South Texas, Corpus Christi, Texas
Art Museum of Southeast Texas, Beaumont, Texas
Asheville Art Museum, Asheville, North Carolina
Auckland Museum, Auckland, New Zealand
Austin Museum of Art, Austin, Texas
Azabu Museum of Arts and Crafts, Tokyo, Japan
Ball State University Museum of Art, Muncie, Indiana
Beach Museum of Art, Kansas State University, Manhattan, Kansas
Berkeley Art Museum, University of California, Berkeley, California
Birmingham Museum of Art, Birmingham, Alabama
Boarman Arts Center, Martinsburg, West Virginia
Boca Raton Museum of Art, Boca Raton, Florida
Brauer Museum of Art, Valparaiso University, Valparaiso, Indiana
Brooklyn Museum, Brooklyn, New York
Canadian Clay & Glass Gallery, Waterloo, Ontario, Canada
Canadian Craft Museum, Vancouver, British Columbia, Canada
Carnegie Museum of Art, Pittsburgh, Pennsylvania
Center for the Arts, Vero Beach, Florida
Charles A. Wustum Museum of Fine Arts, Racine, Wisconsin
Charles H. MacNider Art Museum, Mason City, Iowa
Chrysler Museum of Art, Norfolk, Virginia

Cincinnati Art Museum, Cincinnati, Ohio

Cleveland Museum of Art, Cleveland, Ohio

Clinton Library and Archives, Little Rock, Arkansas

Colorado Springs Fine Arts Center, Colorado Springs, Colorado

Columbus Museum, Columbus, Georgia

Columbus Museum of Art, Columbus, Ohio

Contemporary Art Center of Virginia, Virginia Beach, Virginia

Contemporary Arts Center, Cincinnati, Ohio

Contemporary Crafts Association and Gallery, Portland, Oregon

Contemporary Museum, Honolulu, Hawaii

Cooper-Hewitt, National Design Museum, Smithsonian Institution, New York, New York

Corcoran Gallery of Art, Washington, D.C.

Corning Museum of Glass, Corning, New York

Crocker Art Museum, Sacramento, California

Currier Gallery of Art, Manchester, New Hampshire

Daiichi Museum, Nagoya, Japan

Dallas Museum of Art, Dallas, Texas

Danske Kunstindustrimuseum, Copenhagen, Denmark

Daum Museum of Contemporary Art, Sedalia, Missouri

David Winton Bell Gallery, Brown University, Providence, Rhode Island

Dayton Art Institute, Dayton, Ohio

DeCordova Museum and Sculpture Park, Lincoln, Massachusetts

Delaware Art Museum, Wilmington, Delaware

Denver Art Museum, Denver, Colorado

Design museum Gent, Gent, Belgium

Detroit Institute of Arts, Detroit, Michigan

Dowse Art Museum, Lower Hutt, New Zealand

Eretz Israel Museum, Tel Aviv, Israel

Everson Museum of Art, Syracuse, New York

Experience Music Project, Seattle, Washington

Fine Arts Institute, Edmond, Oklahoma

Flint Institute of Arts, Flint, Michigan

Fonds Régional d'Art Contemporain de Haute-Normandie, Sotteville-lès-Rouen, France

Frederik Meijer Gardens & Sculpture Park, Grand Rapids, Michigan

Galéria mesta Bratislavy, Bratislava, Slovakia
Glasmuseet Ebeltoft, Ebeltoft, Denmark
Glasmuseum, Frauenau, Germany
Glasmuseum alter Hof Herding, Glascollection, Ernsting, Germany
Glasmuseum Wertheim, Wertheim, Germany
Haggerty Museum of Art, Marquette University, Milwaukee, Wisconsin
Hakone Glass Forest, Ukai Museum, Hakone, Japan
Hawke's Bay Exhibition Centre, Hastings, New Zealand
Henry Art Gallery, Seattle, Washington
High Museum of Art, Atlanta, Georgia
Hiroshima City Museum of Contemporary Art, Hiroshima, Japan
Hokkaido Museum of Modern Art, Hokkaido, Japan
Honolulu Academy of Arts, Honolulu, Hawaii
Hunter Museum of American Art, Chattanooga, Tennessee
Huntington Museum of Art, Huntington, West Virginia
Indianapolis Museum of Art, Indianapolis, Indiana
Israel Museum, Jerusalem, Israel
Japan Institute of Arts and Crafts, Tokyo, Japan
Jesse Besser Museum, Alpena, Michigan
Jesuit Dallas Museum, Dallas, Texas
Joslyn Art Museum, Omaha, Nebraska
Jule Collins Smith Museum of Fine Art, Auburn University, Auburn, Alabama
Jundt Art Museum, Gonzaga University, Spokane, Washington
Kalamazoo Institute of Arts, Kalamazoo, Michigan
Kaohsiung Museum of Fine Arts, Kaohsiung, Taiwan
Kemper Museum of Contemporary Art, Kansas City, Missouri
Kestner-Gesellschaft, Hannover, Germany
Kobe City Museum, Kobe, Japan
Krannert Art Museum, University of Illinois, Champaign, Illinois
Krasl Art Center, St. Joseph, Michigan
Kunstmuseum Düsseldorf, Düsseldorf, Germany
Kunstsammlungen der Veste Coburg, Coburg, Germany
Kurita Museum, Tochigi, Japan
Leigh Yawkey Woodson Art Museum, Wausau, Wisconsin

Lobmeyr Museum, Vienna, Austria
LongHouse Reserve, East Hampton, New York
Los Angeles County Museum of Art, Los Angeles, California
Lowe Art Museum, University of Miami, Coral Gables, Florida
Lyman Allyn Art Museum, New London, Connecticut
M.H. de Young Memorial Museum, San Francisco, California
Manawatu Museum, Palmerston North, New Zealand
Matsushita Art Museum, Kagoshima, Japan
Meguro Museum of Art, Tokyo, Japan
Memorial Art Gallery, University of Rochester, Rochester, New York
Metropolitan Museum of Art, New York, New York
Milwaukee Art Museum, Milwaukee, Wisconsin
Mingei International Museum, San Diego, California
Minneapolis Institute of Arts, Minneapolis, Minnesota
Mint Museum of Craft + Design, Charlotte, North Carolina
Mobile Museum of Art, Mobile, Alabama
Montreal Museum of Fine Arts, Montreal, Quebec, Canada
Morris Museum, Morristown, New Jersey
Musée d'Art Moderne et d'Art Contemporain, Nice, France
Musée de design et d'arts Appliqués Contemporains, Lausanne, Switzerland
Musée des Arts Décoratifs, Palais du Louvre, Paris, France
Musée des Beaux-Arts et de la Céramique, Rouen, France
Museo del Vidrio, Monterrey, Mexico
Museo Vetrario, Murano, Italy
Museum Bellerive, Zurich, Switzerland
Museum Boijmans Van Beuningen, Rotterdam, The Netherlands
Museum für Kunst und Gewerbe Hamburg, Hamburg, Germany
Museum für Kunsthandwerk, Frankfurt am Main, Germany
Museum of American Glass at Wheaton Village, Millville, New Jersey
Museum of Art and Archaeology, Columbia, Missouri
Museum of Art Fort Lauderdale, Fort Lauderdale, Florida
Museum of Arts & Design, New York, New York
Museum of Arts and Sciences, Daytona Beach, Florida
Museum of Contemporary Art, Chicago, Illinois

Museum of Contemporary Art San Diego, La Jolla, California
Museum of Fine Arts, Boston, Massachusetts
Museum of Fine Arts, St. Petersburg, Florida
Museum of Fine Arts, Houston, Houston, Texas
Museum of Northwest Art, La Conner, Washington
Museum of Outdoor Arts, Englewood, Colorado
Muskegon Museum of Art, Muskegon, Michigan
Muzeum města Brna, Brno, Czech Republic
Muzeum skla a bižuterie, Jablonec nad Nisou, Czech Republic
Múzeum židovskej kultúry, Bratislava, Slovakia
Naples Museum of Art, Naples, Florida
National Gallery of Australia, Canberra, Australia
National Gallery of Victoria, Melbourne, Australia
National Liberty Museum, Philadelphia, Pennsylvania
National Museum Kyoto, Kyoto, Japan
National Museum of American History, Smithsonian Institution, Washington, D.C.
National Museum of Modern Art Kyoto, Kyoto, Japan
National Museum of Modern Art Tokyo, Tokyo, Japan
Nationalmuseum, Stockholm, Sweden
New Orleans Museum of Art, New Orleans, Louisiana
Newark Museum, Newark, New Jersey
Niijima Contemporary Art Museum, Niijima, Japan
North Central Washington Museum, Wenatchee, Washington
Norton Museum of Art, West Palm Beach, Florida
Notojima Glass Art Museum, Ishikawa, Japan
O Art Museum, Tokyo, Japan
Oklahoma City Museum of Art, Oklahoma City, Oklahoma
Orange County Museum of Art, Newport Beach, California
Otago Museum, Dunedin, New Zealand
Palm Beach Community College Museum of Art, Lake Worth, Florida
Palm Springs Desert Museum, Palm Springs, California
Palmer Museum of Art, Pennsylvania State University, University Park, Pennsylvania
Philadelphia Museum of Art, Philadelphia, Pennsylvania
Phoenix Art Museum, Phoenix, Arizona

Plains Art Museum, Fargo, North Dakota
Portland Art Museum, Portland, Oregon
Portland Museum of Art, Portland, Maine
Powerhouse Museum, Sydney, Australia
Princeton University Art Museum, Princeton, New Jersey
Queensland Art Gallery, South Brisbane, Australia
Reading Public Museum, Reading, Pennsylvania
Rhode Island School of Design Museum, Providence, Rhode Island
Royal Ontario Museum, Toronto, Ontario, Canada
Saint Louis Art Museum, St. Louis, Missouri
Saint Louis University Museum of Art, St. Louis, Missouri
Samuel P. Harn Museum of Art, University of Florida, Gainesville, Florida
San Antonio Museum of Art, San Antonio, Texas
San Jose Museum of Art, San Jose, California
Scottsdale Center for the Arts, Scottsdale, Arizona
Seattle Art Museum, Seattle, Washington
Shimonoseki City Art Museum, Shimonoseki, Japan
Singapore Art Museum, Singapore
Slovenská národná galéria, Bratislava, Slovakia
Smith College Museum of Art, Northampton, Massachusetts
Smithsonian American Art Museum, Washington, D.C.
Sogetsu Art Museum, Tokyo, Japan
South Texas Institute for the Arts, Corpus Christi, Texas
Speed Art Museum, Louisville, Kentucky
Spencer Museum of Art, University of Kansas, Lawrence, Kansas
Springfield Museum of Fine Arts, Springfield, Massachusetts
Štátna galéria Banská Bystrica, Banská Bystrica, Slovakia
Suntory Museum of Art, Tokyo, Japan
Suomen Lasimuseo, Riihimäki, Finland
Suwa Garasu no Sato Museum, Nagano, Japan
Tacoma Art Museum, Tacoma, Washington
Taipei Fine Arts Museum, Taipei, Taiwan
Tochigi Prefectural Museum of Fine Arts, Tochigi, Japan
Toledo Museum of Art, Toledo, Ohio

Tower of David Museum of the History of Jerusalem, Jerusalem, Israel
Uměleckoprůmsylové muzeum, Prague, Czech Republic
University Art Museum, University of California, Santa Barbara, California
Utah Museum of Fine Arts, University of Utah, Salt Lake City, Utah
Victoria and Albert Museum, London, England
Wadsworth Atheneum, Hartford, Connecticut
Waikato Museum of Art and History, Hamilton, New Zealand
Walker Hill Art Center, Seoul, South Korea
Whatcom Museum of History and Art, Bellingham, Washington
White House Collection of American Crafts, Washington, D.C.
Whitney Museum of American Art, New York, New York
Wichita Art Museum, Wichita, Kansas
World of Glass, St. Helens, England
Württembergisches Landesmuseum Stuttgart, Stuttgart, Germany
Yale University Art Gallery, New Haven, Connecticut
Yokohama Museum of Art, Yokohama, Japan

COLOPHON

This second printing of
Chihuly at the Royal Botanic Gardens, Kew
is limited to 7,500 casebound copies.

ISBN 1-57684-153-7

The contents are copyright © 2005 Dale Chihuly
unless otherwise stated. All rights reserved. No part
of the contents of this book may be reproduced
without the written permission of the publisher.

Photographs on front cover and pages 2, 8, 13,
66, 68, 70, 73, 74, 77, 78, 81, and 100 are
copyright © 2005 The Board of Trustees of the
Royal Botanic Gardens, Kew.

*When is a Door a Jar? Dale Chihuly's Uncanny
Materiality* copyright © 2005 Todd Alden.

The History of the Royal Botanic Gardens, Kew
copyright © 2005 The Board of Trustees of the
Royal Botanic Gardens, Kew. Text partly based on an
article published in *Kew* magazine by Peter Goodchild.

The views expressed in this work are those of the
individual authors and do not necessarily reflect
those of the Board of Trustees of the Royal Botanic
Gardens, Kew.

Special thanks to Christopher Thompson, principal
of Studio Lux in Seattle and the United Kingdom.

Photographs Itamar Grinberg, Ron Holt,
Russell Johnson, Tom Lind, Andrew McRobb,
Teresa N. Rishel, Terry Rishel

Design Team Anna Katherine Curfman and Barry Rosen

Typefaces Garamond and Univers

Paper Lumisilk matt art 150 gsm

Printing Rainbow Graphic & Printing Co., Hong Kong

Portland Press
PO Box 70856, Seattle, Washington 98127
800 574 7272 · www.portlandpress.net

Team Antuly

We're less than a month
away from the opening of KEN-
It's been the team work of all
of you that has made this possible -
great work Thanks Antuly
4.27.05